MASTERING
COLORED PENCIL

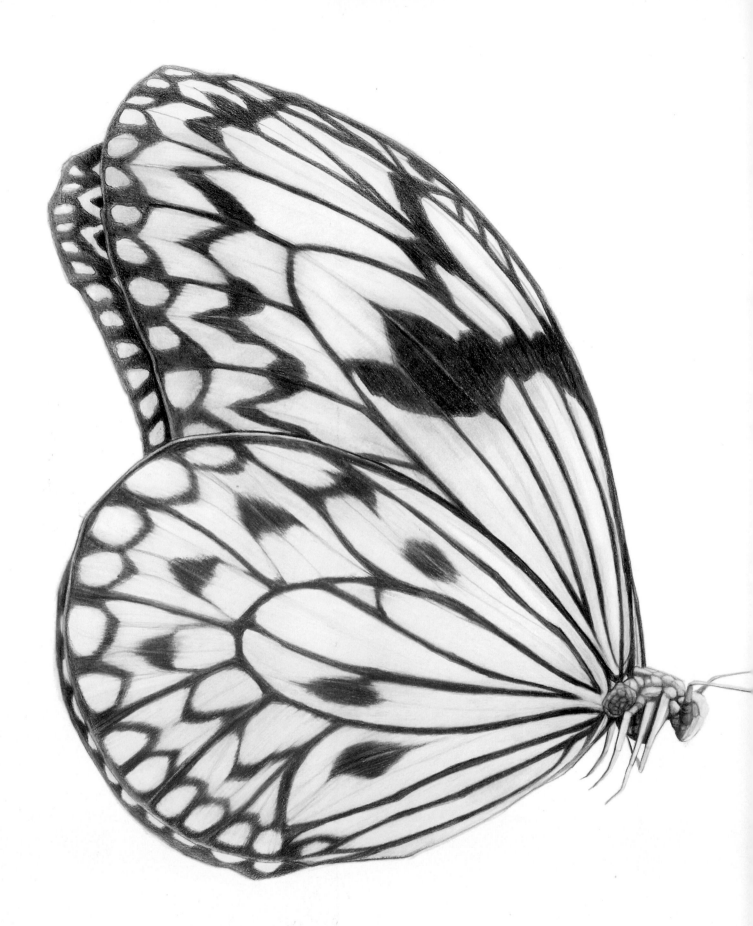

Lisa Dinhofer

MASTERING COLORED PENCIL

AN ESSENTIAL GUIDE TO MATERIALS, CONCEPTS, AND TECHNIQUES FOR LEARNING TO DRAW IN COLOR

MONACELLI STUDIO

Library of Congress Cataloging-in-Publication Data
Names: Dinhofer, Lisa, author.
Title: Mastering colored pencil / Lisa Dinhofer.
Description: New York : The Monacelli Press, 2017. | Includes
bibliographical references.
Identifiers: LCCN 2017006991 | ISBN 9781580934923
(paperback)
Subjects: LCSH: Colored pencil drawing--Technique. | BISAC:
ART / Techniques / Drawing. | ART / Techniques / Pencil
Drawing. | ART / Techniques / Color.
Classification: LCC NC892 .D56 2017 | DDC 741.2/4--dc23
LC record available at https://lccn.loc.gov/2017006991

ISBN: 978-1-58093-492-3

Printed in Singapore

DESIGN BY JENNIFER K. BEAL DAVIS
COVER DESIGN BY JENNIFER K. BEAL DAVIS
COVER ILLUSTRATIONS BY BY LISA DINHOFER

10 9 8 7 6 5 4 3 2 1

First Edition

MONACELLI STUDIO
THE MONACELLI PRESS
6 West 18TH Street
New York, New York 10011

www.monacellipress.com

PAGE 1 Lisa Dinhofer, *Study for Light Travelers # 1* (detail), 2008, colored pencil on paper, 22½" × 25" (57 × 63.5 cm)

PAGE 2 Lisa Dinhofer, *Broadway Butterfly* 2011, colored pencil on paper, 30" × 22" (76 × 56 cm)
Beauty is all around us. Please look for it. My mother found this butterfly on the corner of Broadway and 81st Street in New York City, across from the Museum of Natural History. How appropriate in so many ways.

PAGE 6 Lisa Dinhofer, *Cherries*, 2012, colored pencil on paper, 30" × 22" (76 × 56 cm)

ACKNOWLEDGMENTS

About a year ago, I opened an e-mail with a challenge: to write a book about colored pencils. And so I started this journey. That e-mail was from Victoria Craven, the editor and mentor of this project. I thank her for the challenge and for the beautiful result.

Martha Moran whose editorial skill and patience with me was essential. She turned hours long sessions into a fun, learning time. I thank her.

There are many people who have helped and supported me in this process. I must name two, Tom Duncan and Hilda Adeniji. With an expert artistic eye, Tom read and supplied important insight into the first draft and subsequent pages. His boundless support as my life partner, best friend, and reader I truly appreciate. Hilda is my incredible assistant who worked tirelessly with me. Her grace and good cheer, expertise in all things technology, and credentials as a non-artist reader proved invaluable. This book would have been a very deep challenge without the two of them.

I would also like to thank my fellow artists who agreed to participate in this book. Their work expands the boundaries of this medium.

My students whose work, whether in process or finished, inspires me at all times. Only a few are illustrated here. I thank them as well.

DEDICATION

Finally, I would like to dedicate *Mastering Colored Pencil* to my parents, Norman and Shelly Dinhofer, who passed away within ten days of each other in 2013. They taught me how to love learning with a passion and harness my rather curious mind.

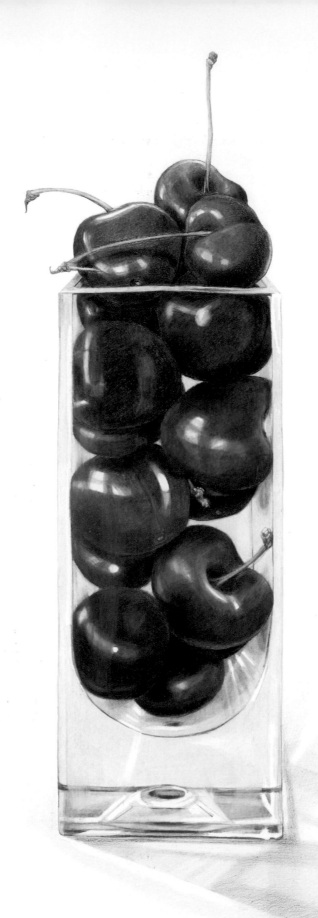

CONTENTS

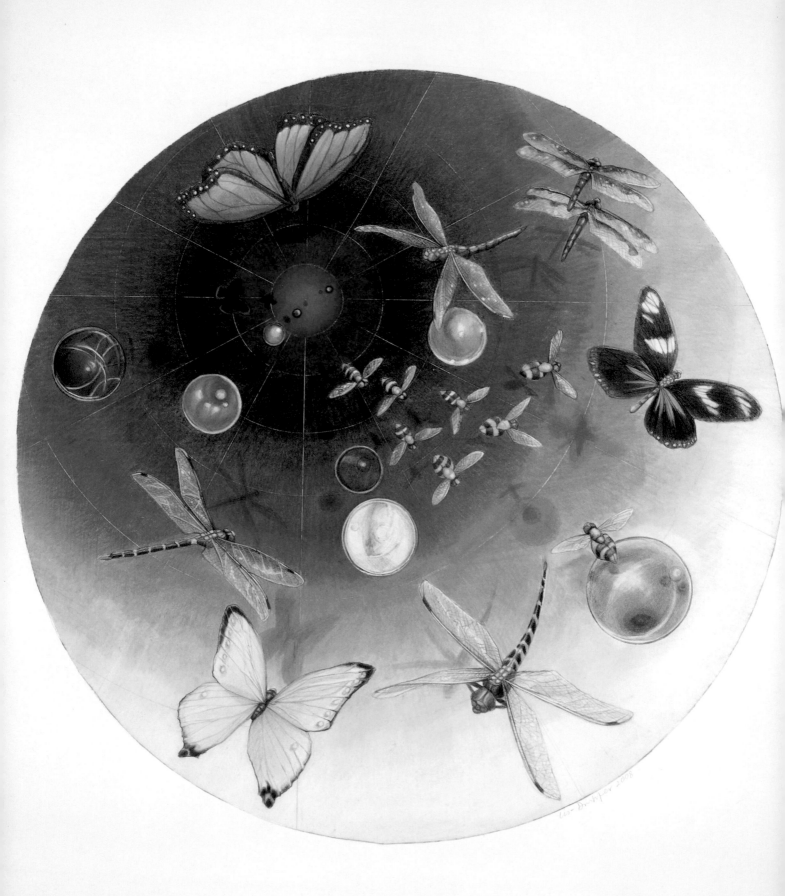

"Art is the only way to run away without leaving home."
TWYLA THARP, CHOREOGRAPHER

INTRODUCTION
Colored Pencil, A New Medium

Colored pencils are coming of age. More and more artists are discovering the incredible qualities of this versatile new medium. So forget the red marking pencil of your third grade teacher. At a recent count there are at least a choice of twenty different reds in the color pencil spectrum of one company, Prismacolor, and an equal amount in several other companies, such as Faber-Castell and Derwent. The choice is wide.

The base of colored pencils varies as well—wax, watercolor, pastel, and graphite. These are medium bases that can be interchanged or mixed together. The effects that can be achieved are limitless. A work in pencil can be a drawing, a watercolor, or an oil painting. Wax and watercolor pencils can sketch, draw, and paint. The drawing can be as transparent as a loose wash or as dense as oils on canvas. You can work as small as a postage stamp or as large as a wall. The scale is up to you.

Colored pencils are portable. Just pack a case with a basic palette of color and set out on an excursion. All you need for a sketch is paper, pencils, and your eye. Sit on a mountainside or just look at what's on your table. There's no need to set up an elaborate painting situation. And cleanup is very simple—pack your pencils in a box, tuck your pad under your arm or in your bag, and off you go.

OPPOSITE
Lisa Dinhofer, *Study for Light Travelers #2*, 2007, colored pencil on paper, 22½" × 25" (57 × 63.5 cm)
Studies for oil paintings can be done in colored pencil. Wax and oil have comparable sensibilities. I prefer doing my studies in colored pencils, such as this one, because I can achieve a true density of color and a high level of detail.

Colored pencils are less expensive than paints—watercolor or oil, so if you later decide this isn't the medium for you, your investment is fairly minimal. And, you can put your pencils aside and pick them up again whenever you want, an hour from now or in a year; the pencils will still be where you left them ready for use.

I discovered colored pencils quite by accident. Like most artists, I spend a good deal of time exploring art stores. At one point I bought a small box of colored pencils or they were a gift. I honestly don't remember. I was working on a large painting, which needed several studies. One day I didn't want to get out all my watercolor paint to make a study, so I looked around my studio and saw this

unused box of colored pencils. I completed my study with them and became intrigued. Several years later I'm still intrigued.

For the purposes of this book, we will be working with three different types of pencil—wax, watercolor, and graphite, and I'll discuss various techniques I developed for using said pencils. Since we'll be working with color, an essential part of mastering this medium is a basic knowledge of how color works as an integral ingredient to making a successful image. I created a series of color exercises, in the form of grids, which allow the student to easily and directly experience the effects of various color pencils and colored pencil techniques, as well as several observational studies. I provide blank grids and art through-

BELOW
Lisa Dinhofer, *Study for Light Travelers #1 & #2*, 2006, collage and colored pencil on paper, 19½" × 24" (49.5 × 61 cm)
This drawing is a study for two large paintings. I wanted to see how the two images would work together on the same wall. In order to see this idea I placed the designs side by side on the same piece of paper.

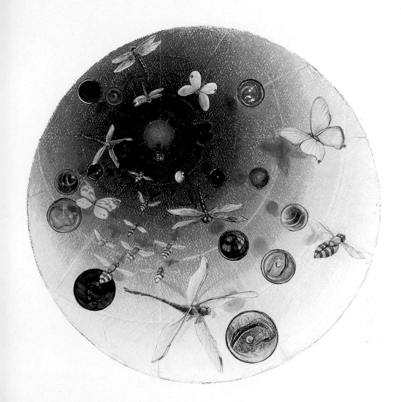
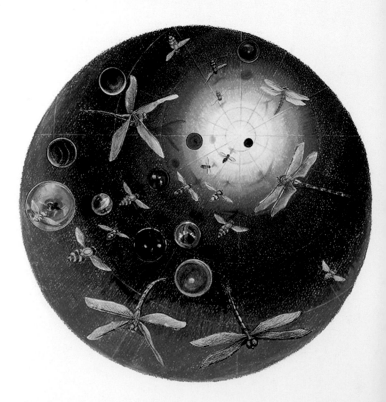

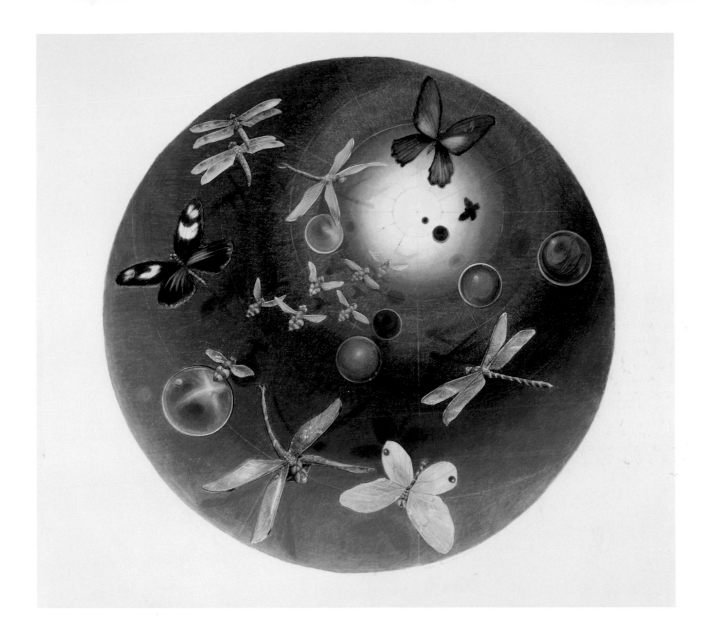

out the book that you can use to reinforce the lessons and as personalized references for your own work.

At the conclusion of most chapters I'll give you a "homework" assignment. In my classes I always give specific homework because it reinforces what we have been doing in class and gives you, the student, a chance to play with an idea and be independent. Along with each homework assignment I include a related drawing done by one of my students. When you complete all the homework and exercises, you will have a wide working vocabulary of color pencil technique. I hope you will take off

from there and be experimental. Remember there are no mistakes, no wrong ways of doing anything, just learning experiences.

At the end of the book, I curated a gallery of contemporary colored pencil art from myself and some of the preeminent visual artists working today: Dotty Attie, Ken Carbone, Tom Duncan, Audrey Flack, Dan Gheno, Fred Marcellino, and Costa Vavagiakis. Each artist also offers a personal statement as to how and why they chose colored pencils as their medium. The Gallery is followed by a brief bio of each artist.

ABOVE
Lisa Dinhofer, *Study for Light Travelers #1*, 2007, colored pencil on paper, 22½" × 25" (57 × 64 cm) Space without end is the goal of the Light Traveler's series. This detailed drawing is the study for a larger circular painting, 44" (112 cm) in diameter.

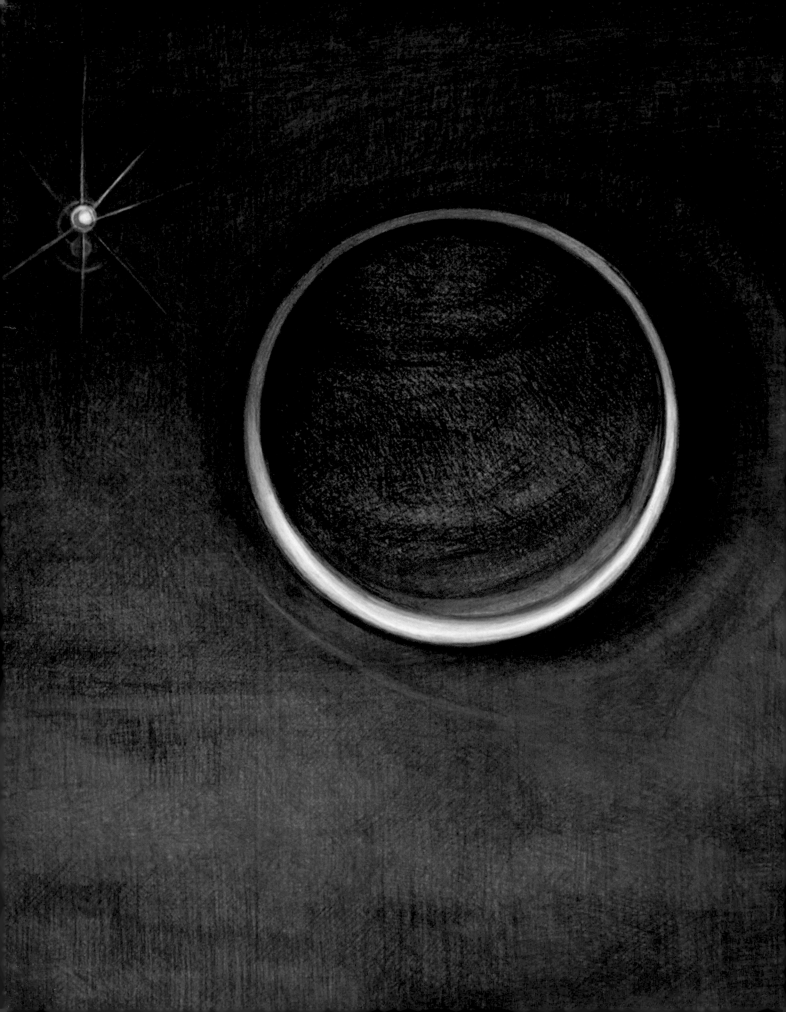

"*The supreme misfortune is when theory outstrips performance.*"
LEONARDO DA VINCI, PAINTER, INVENTOR, DRAUGHTSMAN

IN THE BEGINNING, *OR JUST START*

|||

HOW DO YOU START A NEW MEDIUM? How do you start a walk in the park? How do you start any new endeavor?

A walk in the park, simply one foot in front of the other? Not quite. First you need to get dressed and get to the park (which if you live in a city like I do, can involve some calculations); only then can you put one foot in front of the other. When you think about it, setting up for a colored pencil drawing may well be easier than the proverbial walk in the park. So let's get dressed.

OPPOSITE
Lisa Dinhofer, *Lunar Eclipse #1*, 2011, colored pencil
on paper, 30" × 22" (76 × 56 cm)

BASIC SUPPLIES

I designed this basic supply list to give you a running start with the media. It's the same list I give to all my color pencil students. In the course of the book, you will use all of these materials, and we'll explore a variety of techniques for using all of them.

Pencils

- Drawing Pencils, 1 each: #2B, #8B
- Prismacolor Premier Individual Pencils: 12 colored pencils, sharpened (plus 1 black and 2 white pencils):
 - 2 blues: True Blue, Ultramarine
 - 2 reds: Crimson Red, Poppy Red
 - 2 yellows: Canary Yellow, Lemon Yellow
 - 2 oranges: Spanish Orange, Orange
 - 2 purples: Violet, Mulberry
 - 2 greens: True Green, Spring Green
 - 1 black
 - 2 white
- 1 blending pencil (no color; purchased separately from color pencil sets)
- Prismacolor Premier Sets, two options:
 - 48 pencil set (plus 1 Lemon Yellow, purchased separately)
 - 72 pencil set

Paper

- 1 bristol board pad, 9" × 12" (23 × 30.5 cm), 20 sheets
- 1 pad of tracing paper

Other Essentials

- Erasers: 1 kneaded, 1 plastic
- Pencil sharpener and plastic container for shavings
- ½-inch artist tape (Scotch low tack recommended)
- 1 bottle of art masking fluid, 4-ounce or smaller
- 1 small bottle solvent, turpenoid or gamsol
- 1 tube Krazy Glue (the bottle with the brush is recommended)
- 1 large brush (a makeup powder brush can work)
- Several makeup sponges in various sizes
- Cotton swabs for eye makeup

THE COLORED PENCIL

The colored pencil medium just keeps growing. Each time I visit an art store there is a new pencil or a new pencil auxiliary product. There are now many companies that specialize in colored pencils.

First, let's look at the two essential characteristics of a good color pencil: the intensity of pigment (color) and the consistency of the binder (e.g., wax). The wood shaft should fit comfortably in your hand.

The range of color in pencil form is vast. Each company has its own formulas and therefore pencils from each company have different properties. Experiment with different pencils from a variety of companies to find the type of pencil that best fits your needs.

Comparing Pencils from Different Companies

To demonstrate the different properties of pencils from various companies, I chose one color, Ultramarine Blue, and bought that color from each of the four major manufacturers: Prismacolor, Derwent, Faber-Castell, and Caran d'Ache. (I also bought white pencils from each.) Each company has a wax- (or oil-) based pencil and a watercolor pencil. The chart on page 16 demonstrates the different (and similar) properties of the pencils from each company.

Most of my work is done with pencils from two manufacturers—Prismacolor Premier pencils for the wax-based techniques, and Derwent Inktense for the watercolor techniques. I use them throughout this book. I find the Prismacolor pencil to have the best range of color—150 choices, so far. The pencil runs smoothly and evenly over the surface of the paper. The shaft is easy to handle and sharpen. It is definitely affordable and widely available both in sets and as individual pencils. The one drawback, and it is huge, is that these pencils can break down the shaft during sharpening, which means it may take several tries to get a point when sharpening. I developed specific techniques to correct this, which I'll give to you as we progress through the book.

The Derwent Inktense pencils are color saturated, meaning the pigment is much more intense than other watercolor pencils. Most others are versatile but the washes lack the depth of color I need.

I would like to make this clear: You can and should experiment with different pencils and choose those that work best for you. No one says your pencils have to come from just one or two companies; you may need to combine different pencils from different companies to get the effects you need.

> **NOTE:** *It is not unusual in art supplies such as oil paints, for the name of the color to change with the manufacturer. For example one pencil may be called Ultramarine and another Blue Marine. They are the same color.*

PENCIL COMPARISON CHART

ULTRAMARINE

PRISMACOLOR PREMIER
#PC 902

PRISMACOLOR VERITHIN
#VT 740

PRISMACOLOR WATERCOLOR
#WC 2902

DERWENT ARTIST
#2900

DERWENT COLOURSOFT
#2900

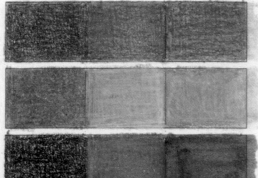

DERWENT INKTENSE (NAVY BLUE)
#0830

FABER-CASTELL POLYCHROMOS
#110120

FABER-CASTELL ALBRECHT DÜRER WATERCOLOR
#117620

CARAN D'ACHE PABLO
#140

CARAN D'ACHE SUPRACOLOR SOFT
#3888

Ultramarine Comparison Chart
Please note how each pencil reacts, the similarities and differences.

PENCIL COMPARISON CHART

ULTRAMARINE

KEY	PENCIL	PENCIL + WHITE	PENCIL + SOLVENT (OR WATER)

You can also do your own comparison chart. Just use this template.

THE DRAWING (GRAPHITE) PENCIL

Drawing pencils are made of graphite. Graphites come in different grades, hard and soft. H means hard and B means soft. The higher the number on the pencil, harder or softer it is. For example 2H is softer than a 9H and 2B is harder than the 9B. See the Graphite Pencil Chart below.

We will be working with 2B (shown here) and 8B drawing pencils. I prefer to do preliminary sketches and drawings with a soft pencil, because the harder the pencil, the greater the chance of leaving an embossment (indentations and rises) on the page. Embossing is a technique we will discover, but it needs to be a choice.

This colorless blending pencil is an essential tool for color pencil drawing. It smooths the pencil stroke, intensifies the color, and creates an even color transition from object to object, and stroke to stroke. It can also be used as an in-between layer of wax for the next layer of color. These pencils do not come in the sets and must be bought separately.

THE COLORLESS BLENDING PENCIL

The colorless blending pencil is just what its name implies. The shaft is wax that has no color or pigment added to it. Each manufacturer has a different name for this pencil; here are three: Prismacolor—Colorless Blender; Derwent—Burnisher or Blender; Lyra—Blender.

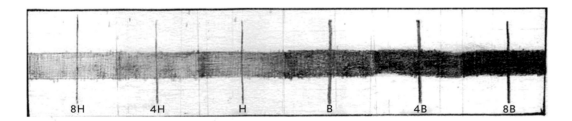

Graphite Pencil Chart

PAPER

Ah, paper. One of my great pleasures is going to a great art supply store, my answer to the movie *Breakfast at Tiffany's*. In New York City there was such a store, New York Central. The second floor was dedicated to paper—racks upon racks of different papers from around the globe. I would stand among those racks looking and touching in order to discover a new paper to try. Unfortunately, New York Central closed in 2016, a great lost to the art community of New York City. It is now in the realm of legend. How do you experience paper? Touch the sheet, feel the texture and weight, and look for color. Color of paper varies even in whites. Choosing a paper is an important factor in achieving the results you want. Following are some things to keep in mind.

Fiber Content: Cotton/Rag

The highest quality paper is 100% cotton (rag). This paper can handle a heavy workload, including many erasures, layering of color, and a variety of techniques without showing too much wear. Papers that are not 100% cotton but are called rag or cotton will not hold up as well. Most important, cotton or rag papers can last hudreds of years. The most iconic drawings of our most admired artists (like Rembrandt, Leonardo, and Turner) were done on 100% cotton/rag.

Fiber Content: Cellulose/Wood Pulp

Cellulose papers are made from wood pulp. They have an acid content that will eventually destroy the paper and consequently your work—the more acidic the paper the shorter its lifespan. Think of a brittle old newspaper that disintegrates at the touch. The one advantage of cellulose paper is that it's inexpensive. There are now buffers put into the paper that can neutralize the acid, so look for Ph-balanced paper when working with cellulose papers.

There are two kinds of paper content: cotton (or rag) and cellulose (or wood pulp). The paper you select is as important as your pencils. Experiment to find which work best with your pencils and techniques.

Texture or Finish

Most manufacturers of high-quality papers offer several kinds of textures and will specify whether the paper is primarily for drawing, watercolor, or printmaking. We will mostly use printmaking and watercolor papers. Each texture specified comes in three different varieties: rough, cold press, and hot press.

Rough, has a deep texture, the natural result of a sheet that air-dried without being pressed. I do not recommend rough for color pencils. It is best for watercolor and pastel because the pigment will pool within the recesses of the texture. Cold press has a slight texture and is very versatile. The paper is pressed between cold wet rollers in the drying process. The hot press produces a very smooth paper.by running the wet paper through hot rollers. Think of a clothes iron—the texture is gone, the surface flat. I recommend hot press for color pencil because it works well for highly detailed images as well as combinations of many different techniques.

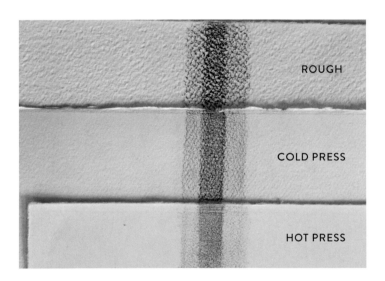

ROUGH

COLD PRESS

HOT PRESS

Paper textures from top: rough, cold press, hot press.

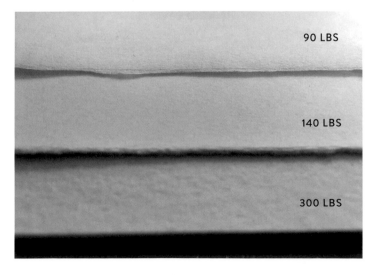

90 LBS

140 LBS

300 LBS

Paper weights, from top: 90 lbs, 140 lbs, and 300 lbs

Sizing

Sizing is added to paper to make it water resistant. It allows the paper to retain the brilliance of the pigment by not absorbing the color. It also allows for a crisper edge that will resist bleeding. Watercolor paper is sized. Printmaking paper and drawing papers much less so. If you are using watercolor pencils, sizing helps so select a sized paper. Printmaking paper is made to be soaked in water before it goes through the press, so sizing is counterproductive. It is very sturdy and works well with wax pencils.

Weight

Papers come in a variety of weights, ranging from copier paper at 20 pounds to 300-pound heavy-duty sheets that feel like thick pieces of mat board. The heavier the paper, the thicker and sturdier it is, and the more it can handle. Heavier papers are thicker to the touch, and a good one can accommodate a multitude of techniques, including water and solvents, embossing, layering, and many erasures.

A paper's weight is the number of pounds in one ream (usually 500 sheets). I prefer 140-pound papers for color pencil because this heavier paper allows for more erasure,

more layering, and just more. It will also retain its structure. In other words, it won't buckle as easy as a lighter paper will. If you are working with watercolor pencil you might want to go up to 300 pounds because it will not warp or buckle when damp or wet, which means it will not need to be stretched. Please note, the heavier the paper the heavier the cost.

Format: To Pad or Not to Pad

Paper comes in several different formats: pads, books, individual sheets, and blocks (a stack of paper bound together on all four sides and mounted on a sturdy back board, see photo on page 102). Pads and books are good for sketching and working out ideas. They are also portable and are easy to handle outside. Individual sheets are used for more complicated, detailed work that you want to work on for a long period of time, several days or longer. With an individual sheet of paper you can cut and shape it to the shape and dimensions you require. A block works really well with all wet media as it eliminates the need for stretching. Once the painting is dry, you remove the sheet by inserting a knife between the layers of paper and carefully breaking the seal of the binding.

When experimenting with the new medium of color pencil, it is best to start with a paper that has weight and some texture but is not very expensive. For the purposes of this book, which has many experiments and exercises, I suggest a 20-sheet pad of white bristol paper, vellum not smooth. (Smooth has too much sizing and is resistant to the medium.)

For my work I use a variety of papers. My favorite at the moment is Fabriano Artistico hot press, 140 pounds, bright white in single 22" × 30" (56 × 76 cm) sheets. This paper is very versatile and can withstand solvent, water, and the multitude of punishments I put it through. I can work as long as I need to, which is sometimes several weeks. I have also used Fabriano Tiepolo, Rives BFK, and Arches Cover. All are white, individual sheets and 140 pounds. I'll talk more about paper in Impressing (page 82).

> TIP: When shopping for paper, keep in mind that the first word of the name is the company—Fabriano, for example. The second word is the name of the paper itself—i.e, Artistico.

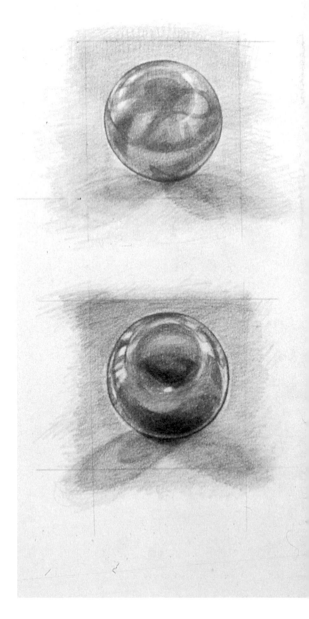

Lisa Dinhofer, *Two Marbles*, 2003, pencil on paper, 13" × 15" (33 × 38 cm)
This two-marble sketch is a drawing from one of my sketchbooks. I drew the same marble with two different light sources in order to decide which one was best for the painting I was composing.

Kneaded eraser

Plastic eraser

AUXILIARY SUPPLIES

Here are the other supplies you'll need when working with colored pencils, from erasers and pencil sharpeners to drawing boards and your studio setup.

Erasers

For a color pencil drawing, two different erasers are needed: a kneaded eraser and a plastic eraser.

A *kneaded eraser* feels like soft rubber or putty. If you ever played with Silly Putty as a child, it is close to that texture. A kneaded eraser is malleable, so you can shape it with your fingers. You can also clean the eraser by stretching and turning it over on itself as if you are kneading bread or for that matter clay. This eraser is primarily used for graphite, your drawing pencils, and comes in square and rectangular shapes.

The *plastic eraser* is white and is made of plastic not rubber. The plastic eraser erases wax and is the implement you will use with your wax pencils. I would suggest two different formats or shapes of eraser: one is a rectangle, which is good for removing large areas, the other comes in a dispenser and looks like a pen. The pen eraser is good for detail and precise work. You will find that your erasers are not just for eliminating mistakes but can also be used as drawing tools.

WRONG

TIP: When you are buying individual pencils, inspect the end of the pencil for centered leads. An off-center lead will never sharpen properly

End/cross-section diagram of a pencil.

RIGHT

Plastic pen eraser

Pencil Sharpeners

Of course you'll need sharpening tools for your color pencils, and finding the best sharpener for your needs requires some thought and some experimentation. There are three different methods for sharpening pencils.

Small handheld sharpeners make a very sharp point and are portable. Easy to control, you can adjust the pressure of your hand in order to get the point required. You can also feel when the lead is about to break and adjust accordingly. I recommend the exposed blades rather than the blades enclosed in a plastic or glass jacket because it is easier to adjust your pressure when you can see the pencil. These sharpeners dull easily, but they are relatively easy to replace since they are inexpensive.

Using an *X-Acto knife, mat knife, or single-edged razor blades* will take some practice. Use caution because you are working with a very sharp exposed blade. Make sure you have a cover for your X-Acto knife, use a retractable mat knife, and keep the sharp edge of your single-edged razor blade covered with tape or cardboard when not in use. Blood is not the best art supply. These tools are good if you want a different kind of pencil edge, such as a chisel point for a flat stroke. A *sandpaper block* can be used to shape and finish your point.

There was a time when *rotary action sharpeners (manual or electric)* ate the color pencil completely. Technology in all areas advances, and there are now rotary sharpeners that can handle color pencils. A rotary sharpener is faster and may be more convenient if you are working in one place, but they do have a tendency to clog, so you need to clean them. Check the manufacturer's instructions to make sure you are using the right one for your pencils.

After experimenting with all types, I found that small handled sharpeners work the best for me. Stopping to hone the point gives me time to think of my next stroke or color. I keep several sharpeners at my drawing board along with a plastic take-out food container for the pencil shavings, which makes disposal simple at the end of the day.

Handheld sharpener

X-Acto knife and razor

Rotary action sharpener

Electric sharpener

Pencil Extenders and Superglue

If you are at all like me eventually you will sharpen your pencil down to where you can barely hold it. There are two ways of extending the life of the nibs (the left over pencils). See Chapter 4 for more details about extenders and extending pencil life with superglue.

> **TIP:** *Notice that the name of the pencil color and the ID number are printed on the shaft at one end of each pencil. Make sure you sharpen at the opposite end so that the color and number remain visible. As you get close to the end of the pencil, write down the name and number so that you can easily replace it.*

A ***pencil extender*** is a shaft of wood with a tube-like metal fastener at one end. Place your nib in the metal receptacle and tighten. This tool will lengthen your pencil's life for one or two more sharpenings. See *Extending Pencil Life Using Superglue* on page 86 in Chapter 4 for more details.

Solvents

Solvents can create a fluid line or a wash by melting the wax of the color pencil. You apply them using a brush, sponge, or Q-tip. We will explore such techniques fully as the book progresses.

There are several kinds of solvents:

- *petroleum based* such as turpenoid or gamsol
- *citrus based*, such as Zest-it
- and *alcohol based*, such as Blender pens

When your pencil nib falls from the extender, you can bind it to another *new* pencil of the same color using ***superglue***. Place a dot of glue, or brush on a tiny portion of glue, onto the flat, unsharpened end of the new pencil. Place the flat end of the nib directly onto the flat end of the new pencil, lining the shafts up, and hold together until the glue sets. It may take a little practice to line the shafts up, but I have found this method extremely successful and it has saved me money and time. See *Extending Pencil Life Using Superglue* on page 86 for more details.

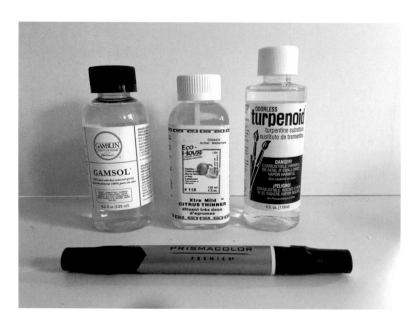

Solvents, from left: gamsol, Zest-it, and turpenoid. In front: Prismacolor.

Masking Fluid, Masking Film, and Artist Tape

The basic idea of a mask is to protect the white of your paper. Masking fluid, masking film, and artist tape put a material barrier between the paper and your medium. (In watercolor it keeps the paper from being saturated with color while you are working an area.) It can be easily removed to reveal the paper. This technique comes in handy when you need to frame your drawing, save a brightest highlight, or protect one area as you work another.

Masking fluid comes in a bottle and is a liquid rubber. It can be painted on, looking like a brushstroke, or it can be shaped to fit a small area. Once applied you must wait till it is completely dry before working over it. Masking fluid can be removed with your finger, tweezers, or a tool called a "pick up." Apply the fluid with a very old, coarse brush, a disposable one, or a cotton swab. If you decide color pencil is the medium for you, invest in a "colour shaper," a rubber-tipped brush and my favorite tool for applying liquid mask.

Masking film is commonly known as frisket. It's a clear film that comes in sheets and peels off a wax paper backing. It can be cut to a shape and applied to your drawing. You can also create a stencil with it.

Artist tape is a low-tack tape that is applied to the paper to create a straight line. You can use it to create a frame around your drawing or cut and shape it.

Tracing paper is so thin you can see through it, a handy feature for tracing. It is very useful for working out drawing problems and transferring drawings from one page to the next.

When you work with individual papers, you will need a *drawing board* (hard backing) to work on. Be sure your board has a smooth surface, is light enough to move easily, and will not resist the tape securing your drawing to it. Drawing boards are available in most art stores. The smallest board I would recommend is 18" × 24" (46 × 61 cm). Smaller works can be fastened to the cardboard backing of a sketch pad.

Masking film

Artist tape

Tracing paper

Drawing board

Alternative Sources for Art Supplies

As we near the end of the supply list, it seems a good place to discuss alternative sources for your art supplies. From sponges to cotton swabs to take-out plastic containers to brushes, art supplies are available in more than art and hobby stores. I've found some of my best tools in drugstores and hardware stores.

Whether you use makeup or not, the makeup section of your local drugstore or department store is a great source of a variety of sponges, brushes, and other tools for your drawings.

- A large powder brush is good for removing pencil and eraser residue and keeping your paper clean.

- A plastic take-out food container is essential for holding your shavings as you sharpen the pencils.

- Very small glass jars such as baby food jars and tiny jam jars are a great way to hold solvent and water since they have a tight lid. Solvent won't dissolve glass as it would do with plastic.

- An inexpensive or disposable eyeliner brush is good for applying masking fluid and solvent.

- Makeup sponges (not household sponges) are a good tool for spreading solvent and water.

- Eye makeup cotton swabs are a must. They are different from regular cotton swabs. They are densely packed and are shaped in points or a wedge.

- Eye Tees and Nail Tees are two products I find incredibly useful for applying masking fluid and small blending areas.

- You will also need paper towels for blotting and cleanup. Be resourceful and experiment.

Makeup sponges

OPPOSITE: Lisa Dinhofer, *31 Marbles and a Mouse*, 1997, pencil on paper, 15" × 13" (38 × 33 cm) This drawing was a very detailed study for a painting. It is the exact same size as the painting. I work out all my compositional problems in a drawing first.

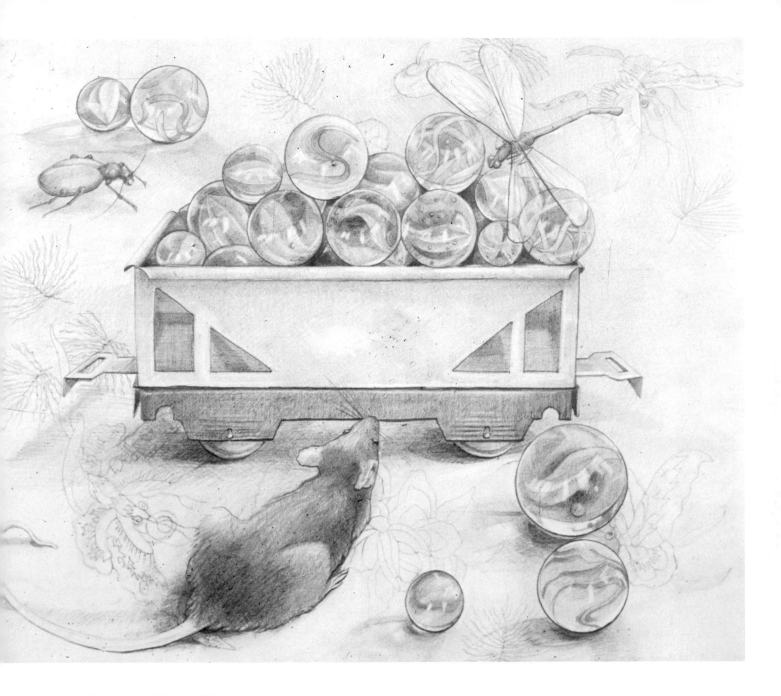

Chinese White (Watercolor) and Acrylic White Paint

The purists of watercolor painting consider using a white paint to enhance highlights to be cheating. I feel whatever gives you the result you want is fine.

The white paint rides the surface of your paper. Therefore if a highlight is missed you can replace it with white. This technique will be explored more as we get further into the book.

Acrylic white paint is good for wax-based pencils.

Chinese white watercolor is good for watercolor pencils. It comes in small tubes and is usually found in the watercolor section of the art store.

Studio Setup

My studio is set up for all media. My large windows face northwest, which means the light is consistent throughout the day. It also means that I will never leave this place. I like mobility when I'm working in colored pencil. I might want to do a large piece on an easel or a study at a table. Therefore, I set my pencils up on an old television stand that is on wheels, and I happily roll it wherever my fancy leads me.

You will eventually find your own ideal set up. The most important thing is to start.

Some tips for setting up a workplace:

- For colored pencil any surface will do—a desk, a standing easel, a table easel, or a kitchen table. The most important tip I can give you is to be comfortable.

- Set your pencils up so that you can see them and grab them easily. Have your erasers, sharpeners and other auxiliary tools in easy reach. Don't worry about messing up the order of your pencils. It happens and is part of the fun.

- Find a well-lit area. Try working in different lights and at different times of day. Try by a window for example, and then try by artificial light.

OPPOSITE: Lisa Dinhofer, *Lunar Eclipse #2*, 2011, colored pencil on paper, 30" × 22" (76 × 56 cm)

In this moon study, I used a solvent wash in the background. This allowed me to cover a large area with color. I then layered more color onto the surface by using the pencils directly.

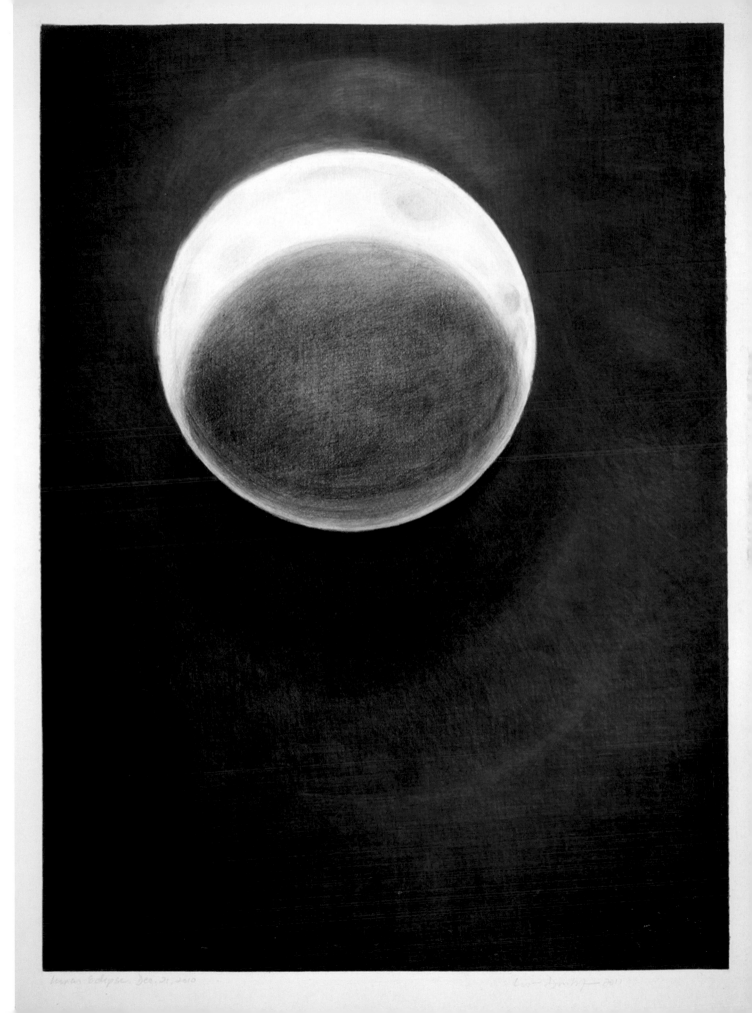

Lunar Eclipse, Dec. 21, 2010

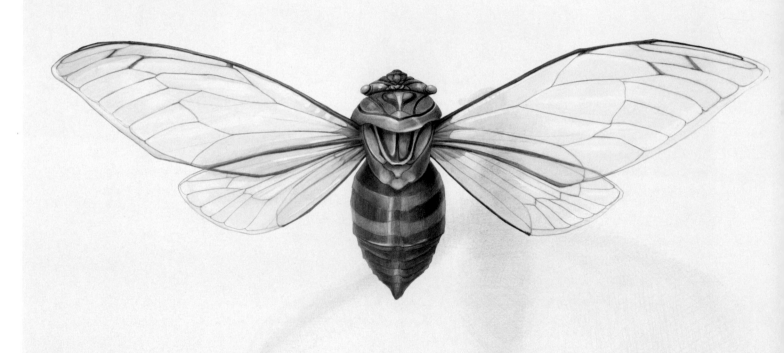

"*The artist never entirely knows—we guess.*
We may be wrong, but we take leap after leap in the dark."
AGNES DE MILLE, CHOREOGRAPHER

PENCIL VOCABULARY
LEARNING ABOUT YOUR COLOR PENCILS

|||

NOW THAT YOU HAVE INVESTED TIME IN LEARNING ABOUT THIS MEDIUM, bought the supplies, and found a place to work, you are poised to start drawing. But how? What can your array of pencils do? Let me stress, the only limits to success with this medium are self-imposed. Once you've experienced what the pencils can do, push, push, and push again. Allow the pencils to surprise you. Experiment, skydive into the medium, play with it, and have no fear. But first a few guidelines will help jump-start your process. It's important to experience the full range, variety, and effects of what color pencils can do.

Lisa Dinhofer, *Cicada*, 2012, colored pencil on paper, 22" × 30" (56 × 76 cm)
The cicada with the open wing is fascinating. It gave me a chance to work on the translucency of the webbing in the wing. I used both the white pencil as a burnisher and the blending pencil to get a transparent quality.

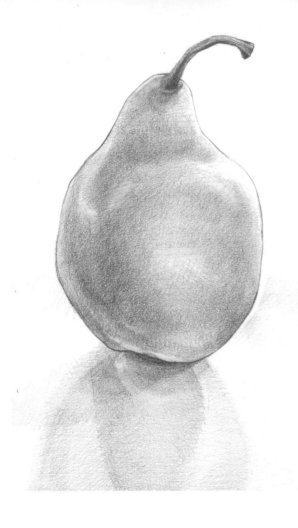

ACHIEVING DIFFERENT PENCIL EFFECTS

There are as many ways to approach a drawing as there are artists. I thought the best way to illustrate the media choices color pencil artists make was to render the same pear four different ways using four different media—graphite, wax color pencil, watercolor pencil, and wax with burnishing and layering. Each drawing is 7.5" × 11" (19 × 28 cm) with the pear taking up 75 percent of the picture plane. I used the same paper for all four drawings: Fabriano Artistico, 140 pounds, extra white. Using the same paper makes it easy to see the textural differences that can be achieved with color pencils.

Graphite Pencil

Supplies: Venus graphite drawing pencil #2B, Prismacolor kneaded eraser

In the graphite pear drawing I used only a #2B pencil and a kneaded eraser. This is a detailed black-and-white rendering. I built the surface of the drawing by a continuous layering of crosshatched pencil strokes. I used the eraser to first correct the initial drawing problems and then to define the highlights. Because you can shape the kneaded eraser, it becomes as much of a drawing tool as the pencil.

Wax Color Pencil

Supplies: Prismacolor pencils, white plastic eraser, pen-shaped plastic eraser

Using only pressure from the weight of my hand and crisscrossing the pencil strokes, I drew this color pencil rendition of the pear as if I was doing a graphite drawing. I slowly built the surface of the pear with a variety of blues, greens, and yellows. The shadows were rendered in purples and blues.

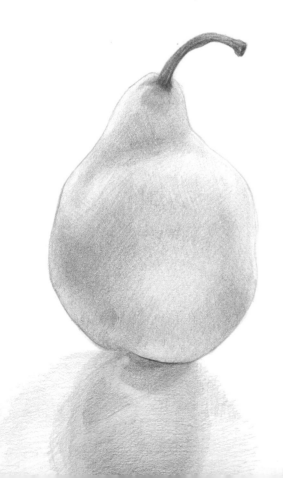

Watercolor Pencil

Supplies: Derwent Inktense pencils, watercolor brush, white plastic eraser

As with the graphite and wax pencil drawings, I built the form here by crosshatching and layering blues, greens, and yellows over the surface of the pear and in the shadows, where I used purples, reds, and yellows. Using a brush dipped in water, I then skimmed the surface, blending the strokes of the pencil together. This creates a wash-like surface. After the paper dried, I went over certain areas again with the pencils to pick up some textural effects.

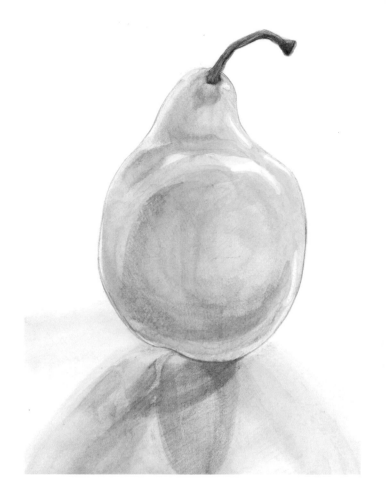

Wax Color Pencil with Blending and Burnishing

Supplies: Prismacolor Premier pencils, white pencil, blending pencil, plastic eraser, pen-shaped plastic eraser

As with the other three drawings, I built this surface with a variety of color pencils. Then, using a blending pencil, I worked the whole surface. After blending, I added another layer of color and then used the white pencil to take the color down a step and give the drawing a glazed, painterly look. The use of the white and blending pencils eliminates the previous pencil strokes and lets you add another layer of color on top. This is a painting technique using color pencils.

Conclusion

Study all four renditions. Each is different. Each embodies a different feel, a different atmosphere. Choosing the technique depends on the mood you want to portray in your drawing. I will do a graphite drawing to learn about my objects: the texture of a dragonfly wing or the transparency of a marble. I will do a color pencil drawing as a color study for subjects that will eventually die, for example a flower. The watercolor pencil drawing and the more elaborate pencil drawing with blending and burnishing are unique pictures complete in and of themselves. In other words each of these techniques has its own purposes and can be applied in a thousand different ways.

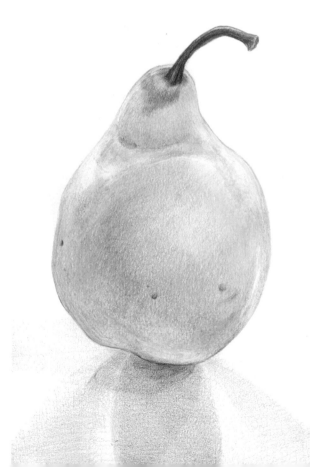

PRISMACOLOR

CRIMSON LAKE

**ULTRAMARINE BLUE +
CRIMSON LAKE**

Effects using a blender (blending pencil).

PRISMACOLOR

CERULEAN BLUE

**LEMON YELLOW + CERULEAN
BLUE**

Here you'll see the effects of *white pencil burnishing*.

PRISMACOLOR
BASE COLOR: MAGENTA

| CREAM | FRENCH GRAY 10% | COOL GRAY 10% | SKY BLUE LIGHT |

Here is an example of *burnishing with color*. Note the changes and the glazing effect. Burnishing can also change the atmosphere and temperature of the surface by creating layers of color. This is a way of painting with color pencils.

BLENDING, BURNISHING, AND SOLVENTS

In both blending and burnishing, you are adding a top layer of wax that alters your previous pencil strokes. Blending and burnishing pencils are also mixing tools. They can smooth the transition between colors.

Blending Pencil

A blending pencil has no pigment. It is a column of wax (Prismacolor) or oil (Lyra) encased in a wood frame (the shaft) of the pencil. The effects are the same. The wax pencil is a dryer and has a crumbly texture. The oil pencil runs a little smoother but doesn't enhance the color as well. If you are working with wax pencils it is better to continue with the same base in your blending pencil. The blender will enhance the color of the color pencil, smooth the stroke (but not eliminate it entirely), and blend two or more colors together (see illustrations). Both pencils can be sharpened with the pencil sharpener of your choice.

Burnishing

Burnishing is a technique unique to color pencil. The closest effect I can compare it to is glazing. In painting, glazing is a technique whereby a light layer of color covers the surface to produce a gradual change. It can enhance the form by building into the darks. For white-pencil burnishing, use the white pencil, which is softer than a blending pencil, to spread a fine film of wax over a designated area of your drawing. This will smooth the surface, remove the hand

strokes, take the intensity of the color down a step, and sometimes change the value slightly.

Burnishing can also be done with light-value *colored* pencils such as Prismacolor Cream, French Gray 10%, Cool Gray 10%, or Shy Blue Light. These pencils have pigment, so they will change the color of the under pencil. See example on opposite page.

Solvents

Basically, solvents melt the wax or oil of your pencil. Therefore a solvent—such as gamsol, turpenoid, Zest-it, or alcohol—it will remove the stroke, enhance the underlying color, and create a wash-like movement on your page. Solvents combined with blending and burnishing will create a color pencil painting.

PRISMACOLOR

POPPY RED

CANARY YELLOW + POPPY RED

Using a cotton swab, sponge, or brush, apply the solvent just to the top layer of wax color pencil. I have found this technique very useful in covering large areas of color quickly. The downside is it cannot be erased, and further layering on top of the solvent-saturated surface is limited. On the other hand the solvent will not buckle your paper, as water will, so stretching the paper is not necessary.

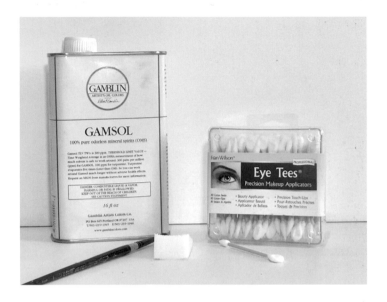

Basic solvent tools: mineral spirits (like gamsol), cosmetic cotton swabs, cosmetic lip or eyebrow brush, makeup sponge.

NOTE: *Do not saturate your paper with solvent. This leaves a discolored border at the edge and can ruin your paper if it is not primed with gesso.*

WORKBOOK EXERCISE: CREATING COLOR PENCIL GRIDS

Throughout the exercises and homework assignments we will be working with the two characteristics of the medium—the "color" and the "pencil" delivery of the pigment—separately and simultaneously. This sounds contradictory but is inevitable since the pencil itself cannot be separated from the color.

I developed this series of exercises that use a simple grid format to show the versatility of the colored pencil. These grids are a teaching tool that demonstrates how the pencils work, including texture, color, and density.

For the following grids I chose groups of specific pencils. They form what is known as a warm/cool palette. (We will get into the variants of color itself in the next chapter, starting on page 47.)

Note: These are primary color variants—red, blue, and yellow. Each color has different properties. Again, I will go into detail in the next section. Right now it is important to get to know your pencils and experience what they can do.

Supplies

- Prismacolor Premier, wax-based pencils
- 2 Blues: Ultramarine Blue, True Blue
- 2 Reds: Poppy Red, Alizarin Crimson
- 2 Yellows: Canary Yellow, Lemon Yellow
- 1 White and 1 Blender pencil
- Solvent (turpenoid, gamasol, Zest-it, or alcohol)

Coloring the Grids

Here, and throughout the book, I'll present one completed exercise grid, and one blank template grid, so you can do the same exercise yourself. I encourage you to do these exercises. They are a very fast way to acquire a working vocabulary of color pencil technique. Here is a breakdown of the process.

1. Label Your Grid

Before applying the colored pencils on the grid, please label your grid following the example of the completed grids that follow. It is important to label your exercise because these grids will be a reference for the particular color. Plus, once the grid is complete, you may not remember what utensil made which effect.

You can repeat this grid for any wax-based color pencil.

2. Row 2: Colored Pencil Plus White for Burnishing

In the second row of the grid, you'll use color pencil plus a white pencil. Using your white pencil is not just for a value change, although it will step down the intensity of your color. As you will observe, the white pencil will also remove your stroke lines. This is known as burnishing. You are putting another layer of wax on the page and smoothing the surface. Color the squares in the second row with your color pencil first, moving left to right, from darkest to transparent as you did in step 2. Then go over each square with the white pencil. The pressure of the white pencil should be uniform across the row.

3. Row 1: Weight of Your Hand for Pure Color

How hard you press down on the pencil will

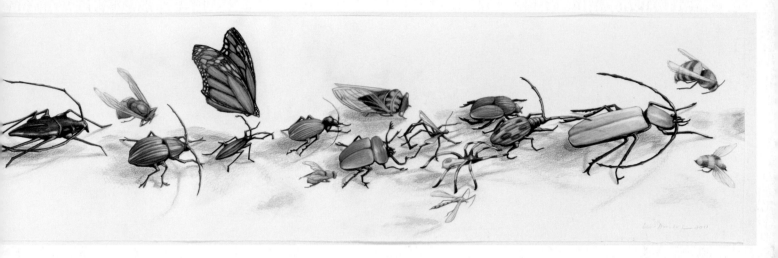

bring out different effects. In the top row of the grid, the color is pencil only. This row acts as your control of the color. In the first box (far left) press down hard on your pencil in order to lay down the densest amount of wax and pigment. In the second box (center) use a medium weight of your hand to create a middle tone. In the third box (far right) use a light hand, hardly pressed down. The white of the page should be apparent with a slight film of color. The three boxes together should feel like a gradation of color across the surface from dense to transparent.

Note: Repeat this process throughout the grid. Each subsequent line should have, from left to right, a dense tone, middle tone, and a light tone of color pencil.

4. Row 3: Colored Pencil Plus Blender for Blending

The blending pencil is devoid of color. It is a shaft of pure wax. The blender will enhance your color and put another layer of wax on the paper. Blending will not remove your stroke entirely but will soften it. Color the third row of the grid with your color pencil as you did in step 2. Then use your blender, pressing uniformly over the applied color. Notice how the blending pencil enhances the color as well as softening your stroke.

5. Row 4: Colored Pencil Plus Solvent

Color the fourth row of the grid as you did the first three rows, then apply the solvent. The solvents for a wax pencil are: turpenoid or gamsol (petroleum derivatives), Zest-it (a citrus derivative), or alcohol. I recommend turpenoid or gamsol. The solvent melts the wax and forms a wash. The effect can be very painterly. It is also a good way to lay down a large swath of color quickly. Your paper is not protected by a primer (like gesso), so it is important that you skim the surface of your color with the solvent rather than saturating it. The solvent may destroy your paper if you use too much. Use a cotton swab, sponge, or brush to apply the solvent.

Lisa Dinhofer, *Bugs on Parade*, 2011, colored pencil on paper, 9" × 31" (23 × 79 cm)
Choosing the configuration of your picture plane (the boundaries of which are the four corners of your page) is essential. Here I wanted to stress the march of the insects. I chose a long narrow piece of paper to enhance the concept of the march.

PRIMARY COLOR GRIDS

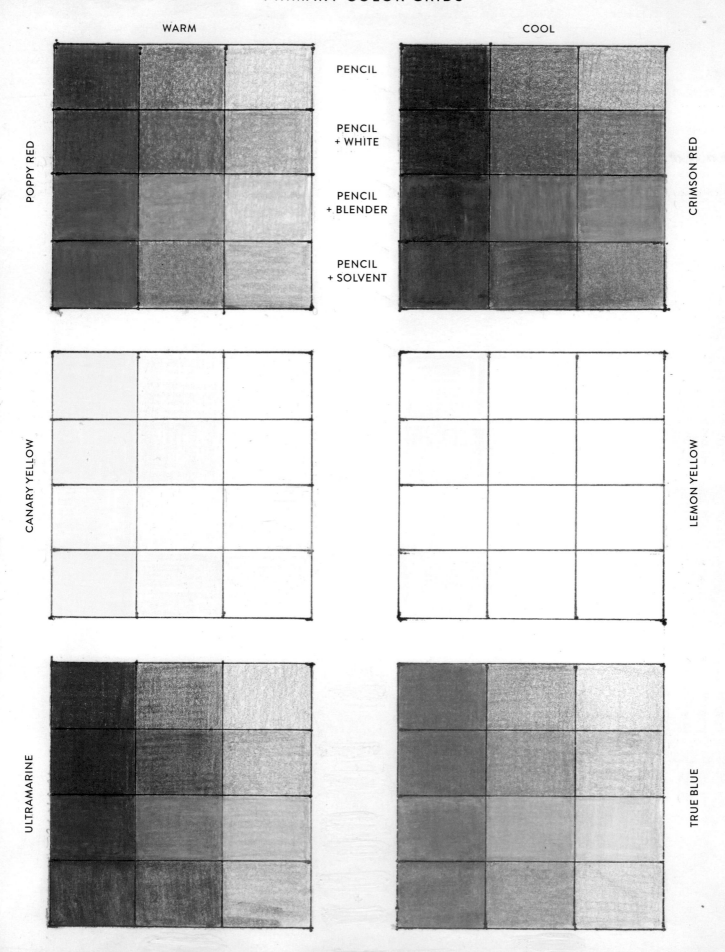

WARM

COOL

PENCIL

PENCIL
+ WHITE

PENCIL
+ BLENDER

PENCIL
+ SOLVENT

POPPY RED

CRIMSON RED

CANARY YELLOW

LEMON YELLOW

ULTRAMARINE

TRUE BLUE

WARM

COOL

SECONDARY COLOR GRIDS

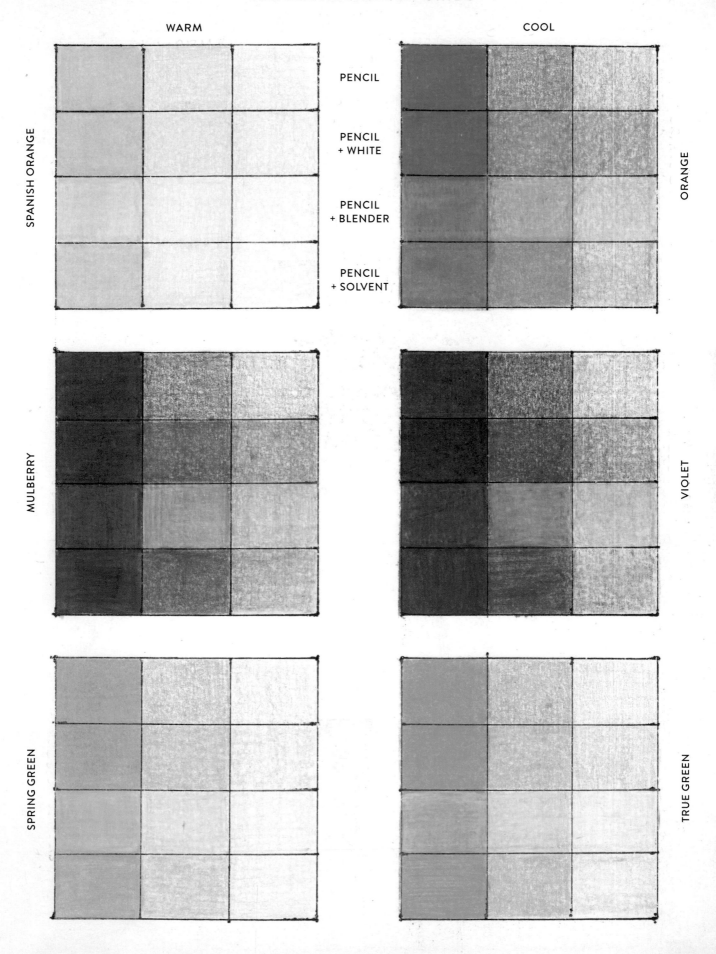

WARM

COOL

PENCIL

PENCIL
+ WHITE

PENCIL
+ BLENDER

PENCIL
+ SOLVENT

SPANISH ORANGE

ORANGE

MULBERRY

VIOLET

SPRING GREEN

TRUE GREEN

Blank Grid Template

SURFACES

Color pencils can be used on many different surfaces. Paper, of course, but you can also experiment on clay boards, gesso canvas boards, or 2- or 4-ply museum board. Any hard, flat, prepared surface will do.

For this book we will concentrate on working on a paper surface. I find paper to be very versatile—the surface can be as smooth as a mirror or rough as a sandy, pebbly beach—the choice is yours. As described in the Supplies section (page 19), paper comes in different weights (how thick is it) and different textures (smooth to rough). The heavier (thicker) the paper, the longer you can work on it and the more punishment it can take—i.e., you can erase many times, add solvent, add layers of pigment, and burnish and blend without damaging the paper. (We will explore other techniques that work on different surfaces as the book progresses.)

The illustrations at right show five different papers of varied weights and textures. I have done a sample on each paper type in order to show the differences in texture and what the pencil can do.

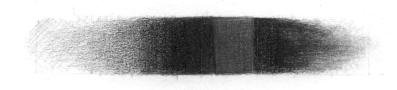

90-pound vellum (from a pad)

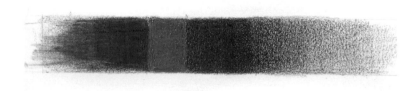

140-pound Fabriano Artistico, Extra White, hot press paper

300-pound cold press paper

140-pound rough paper

2-ply museum board

COLORED PENCIL REFERENCE BOOK

One of the most useful tools in my own studio is the colored pencil reference book. I developed it to solve a basic problem I was having. I like to work my pencils down almost to the

nib, and thereby sharpen away the pencil's color name and reference number. When I found I needed a particular pencil to complete a piece or a passage, I had absolutely no idea what the name or the reference number of that pencil was. I would try to match the color in my art supply store, which sometimes worked but often didn't. After several frustrating experiences I decided to create a reference book where I would color a grid with the pencil and record the color name and reference number under it. Why didn't I just use the color chart from the pencil's manufacturer? Because a printed color chart does not give you the exact color or texture of the pencil. Creating this reference book takes quite a bit of time and is not for the faint of heart. In fact it is something for the totally obsessive person, like me.

The cover and page 37 of my personal colored pencil reference book.

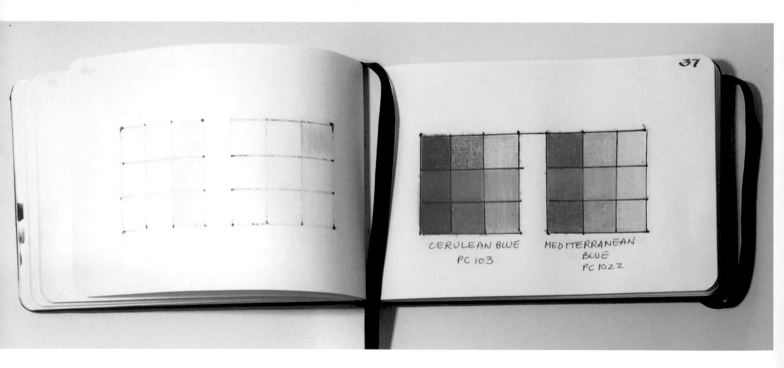

CERULEAN BLUE
PC 103

MEDITERRANEAN
BLUE
PC 1022

MAKING A COLORED PENCIL REFERENCE BOOK

Supplies

- 1 small landscape sketchbook
- I used a 3½" × 5½" book. You can put two colors on each page. Prismacolor has 150 colors, so you'd need at least 75 pages for your references.
- 1 ruler (to map out your grid)
- 1 fine point ink pen (to draw your grid)
- 1 pushpin
- All your color pencils

1. Label your book along with your name and contact information. On the first page, record the pencil company name and pencil type, for example: Prismacolor Premier. Keep each manufacturer separate. You can divide into sections, or use separate books for each manufacturer.

2. Draw your grid using the pen and ruler. I make a nine-box grid three boxes across by three boxes down. In each row, I show the gradation of the color from transparent to dense (light, middle tone, heavy). The first row is for pencil alone, the second row for pencil and blender, and the third row for pencil with white.

3. Your grids should be the same size from page to page. I didn't want to measure a new grid for every page, so I used a pushpin to pierce each corner of the grid through to the next page. You can use these pin dots for ruler placement as you draw the new grid. The more pressure you put on the pin the more pages you will mark.

4. Under each grid, record the name and reference number printed on the pencil, for example, Ultramarine, PC 902.

5. Color your grid as outlined in step 2 above.

Uses for the Colored Pencil Reference Book

There are two main uses for this book. The first is to figure out the name and reference number of any pencil, so it can be replaced. The second is to see what this particular colored pencil can do. As you get further into this medium, knowing the range of the color and the texture of a particular pencil will become important.

How to Use the Reference Book

When your pencil is sharpened past the name and number, take the nib and a swatch of scrap paper and color a square at the edge of the paper. Place the colored swatch against the reference grid. Compare the colors until you find the right one. Now you know the exact pencil you need to purchase.

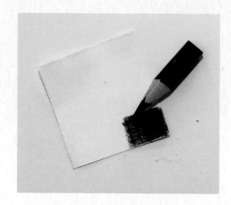

Purple color reference swatch

Laying the purple swatch on the grid.

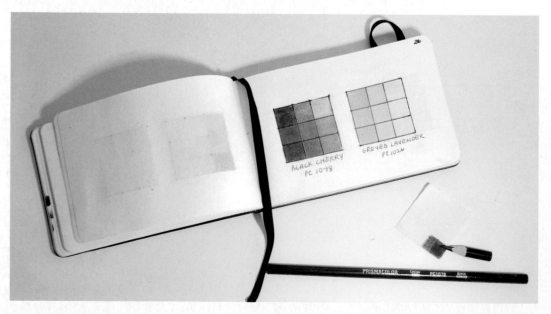

Identifying the correct color for the pencil.

HOMEWORK ASSIGNMENT #1:
DRAW YOUR BREAKFAST

Every time I give this assignment someone will inevitably say, "I don't eat breakfast." My reply is, "You don't eat at all during the day?" Breakfast is simply breaking your fast from the night before. So, think about whatever breaks your fast and draw that.

Edward Zimmerman, 2015, colored pencil, 6¼" × 7" (16 × 18 cm)
Success: Ned's success lies in his color choices. The two dominant colors are primaries, yellow and blue. They are equal and opposite at the same time. This creates a dynamic interaction on the page.

Satoko Takahashi, 2015, colored pencil, 11" × 14" (28 × 10 cm)
Success: Satoko's success lies in her choice of subject: an iconic fast-food sandwich. This choice is personal and universally recognizable at the same time, a reflection of the time in which we live.

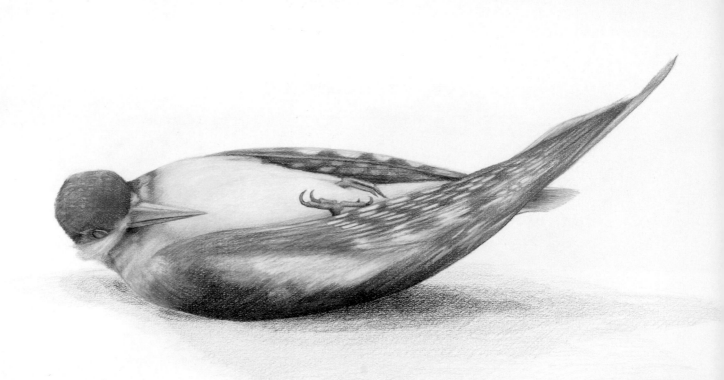

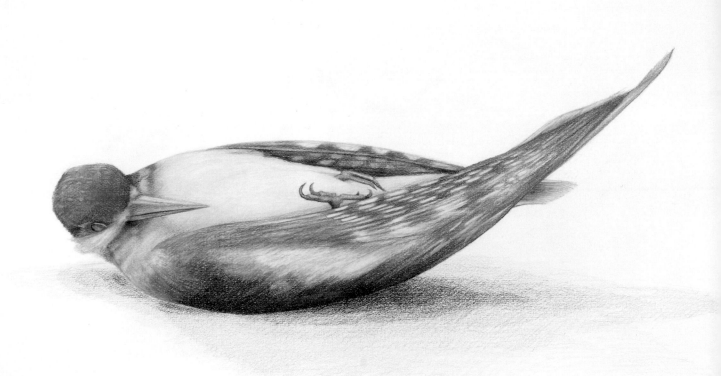

HOMEWORK ASSIGNMENT #1: DRAW YOUR BREAKFAST

Every time I give this assignment someone will inevitably say, "I don't eat breakfast." My reply is, "You don't eat at all during the day?" Breakfast is simply breaking your fast from the night before. So, think about whatever breaks your fast and draw that.

Edward Zimmerman, 2015, colored pencil, 6¼" × 7" (16 × 18 cm)
Success: Ned's success lies in his color choices. The two dominant colors are primaries, yellow and blue. They are equal and opposite at the same time. This creates a dynamic interaction on the page.

Satoko Takahashi, 2015, colored pencil, 11" × 14" (28 × 10 cm)
Success: Satoko's success lies in her choice of subject: an iconic fast-food sandwich. This choice is personal and universally recognizable at the same time, a reflection of the time in which we live.

"*Color is my day long obsession, joy, and torment.*"

CLAUDE MONET, PAINTER

ASPECTS OF COLOR

|||

AH COLOR! Color is an integral part of any visual medium—drawing, painting, graphic design, animation, sculpture, absolutely all. Color sets the mood, the emotion, the temperature, the depth. **Color is magic!** We artists are like magicians because we create illusions on a two- or three-dimensional surface. As with all magicians, our sleight of hand can be learned, but unlike magicians our techniques are not secrets. In this section we will explore the limitless world of color.

Lisa Dinhofer, *Red-Headed Woodpecker*, 2009, colored pencil on paper, 22" × 30" (56 × 76 cm) Note the change in texture between the bird and the ground. The only two elements in the picture plane, they need to be distinct from each other.

These are drawn differently and treated to different techniques. For example in the bird there is a good deal of burnishing, while on the ground I let the texture of the paper come through without layering or burnishing.

THE VOCABULARY OF COLOR

Color is a visual experience. Learning the terminology that explains that experience is essential in understanding the properties of color, what color can do, and what it already does. Some of these elements you know intuitively; some you have to learn.

There are three basic categories of color: *hue*, *value*, and *intensity*, all discussed here. We will be going into these concepts in more detail toward the end of this chapter.

Hue

Hue is simply color or chroma itself. It is the name of the pure pigmentation of a particular color.

Value

Value is the scale of color from light to dark. Within that range/scale, there is *shade*, the mixture of a color with gray or black, and there is *tint*, the mixture of a color with white.

Hues of two colors, blue and yellow.

BLUE YELLOW

Here's an example of creating values of Crimson Red by adding white.

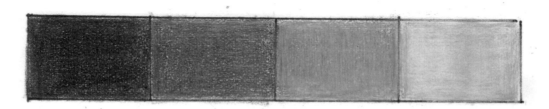

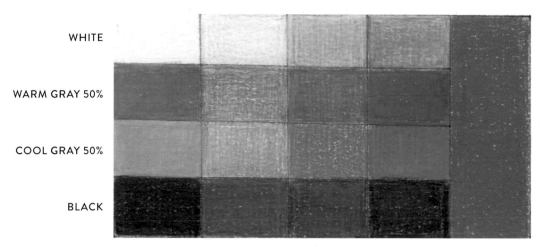

WHITE

WARM GRAY 50%

COOL GRAY 50%

BLACK

TRUE BLUE

**VALUE / INTENSITY GRID:
BLACK TO WHITE**

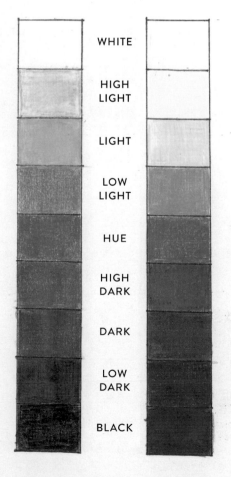

WHITE

HIGH
LIGHT

LIGHT

LOW
LIGHT

HUE

HIGH
DARK

DARK

LOW
DARK

BLACK

There is an interesting difference between the value of a color and the shade of a color. With a tint, the addition of white to change the value of a color does not change the basic property of the color/hue itself. But by adding gray or black to the color to create a *shade* of the color, the essence of the color itself changes. Unlike the color white, black essentially is another color, like red or blue or yellow, when it comes to mixing it with other colors. This is why I have not included the addition of gray or black as an essential property of a color.

Intensity

Intensity is the degree of brightness in the color. Intensity defines the purity and strength of the color. How red is the red you are using?

ABOVE The values (left) and shades (right) of True Blue.

LEFT This is an illustration of value versus intensity. On the left of the scale is the value; on the right is the color intensity.

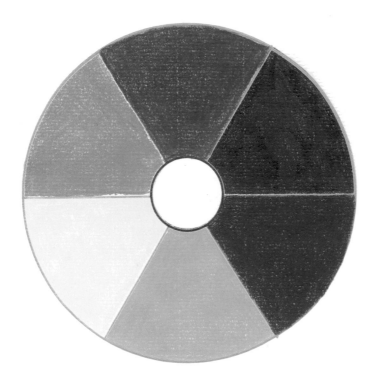

THE COLOR WHEEL

What is the color wheel? Why is it important? The purpose of the color wheel is to organize your colors. As an organizational tool, it allows you to lay out a palette with a quick visual reference. We are taught to write as a means of organizing our thoughts. Learning to organize your palette through the color wheel is in the same vein. You write a sentence with a subject and an object with an action. The create art with the colors of the color wheel: primary, secondary, and tertiary.

Primary Colors

The primary colors are red, yellow, and blue. They are unique an irreducible. These three colors form the base from which all other colors evolve, and cannot be created through mixing other colors. Therefore, red, yellow and blue are the first colors to put on your color wheel and are completely as separate from one another as they can be.

TOP The color wheel showing primary and secondary colors, clockwise from top: red, violet, blue, green, yellow, and orange.

BOTTOM The primary color wheel, clockwise from top: red, blue, yellow.

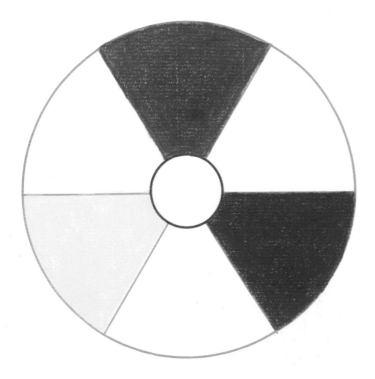

Secondary Colors

The secondary colors are green, orange, violet.
Each is created by mixing two primary colors.

red + yellow = orange
red + blue = violet
blue + yellow = green

Complementary Colors

Complementary colors are two colors that are
opposite each other on the color wheel. For
example, red is complemented by the opposite
color on the wheel, green. When the two col-
ors are placed side by side they vibrate along
the edge. When the two colors are mixed they
are grayed and lose ther intensity.

TOP Secondary color wheel, clockwise from left:
orange, violet, and green.

BOTTOM Complementary color wheels, from left: red/
green; orange/blue; yellow/violet.

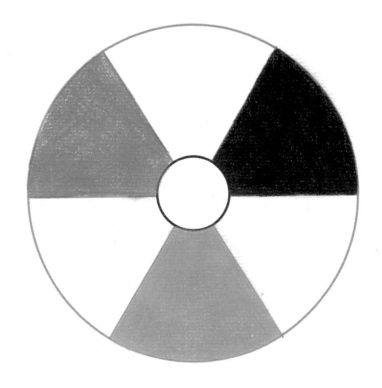

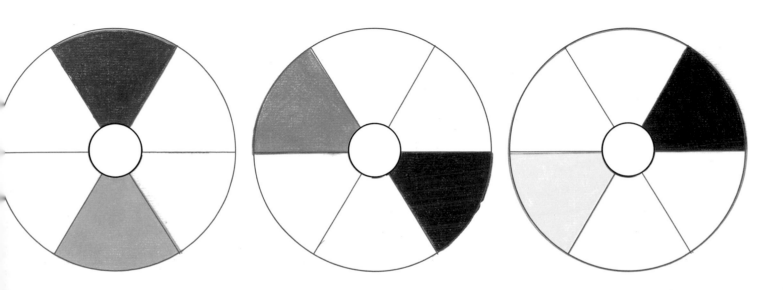

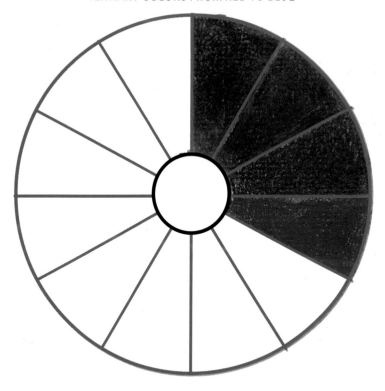

Tertiary Colors

The tertiary colors are the steps between the primary and secondary colors, and are made by mixing a secondary color with a primary color. Look at the color wheel and you'll see that between the primary color red, and the secondary color violet, is red/violet, the tertiary color you get when you mix red and violet together.

The temperature of a color is an essential ingredient. Each of the six tertiary colors—yellow-orange, red-orange, red-violet, blue-violet, blue-green, and yellow green— have both a warm and cool element. Red is a warm color, blue is a cool color, therefore, a warm violet has more red in it and a cool violet has more blue in it.

There are actually two catergories of temperature within each color. Take red, for example: there are two reds within the color wheel. What is the difference between warm and cool? How do you see it? Close your eyes. Think red and then think blue; which color feels hot which cold?

Warm and cool also affect spatial relationships on the picture plane. Warm colors advance while cool colors recede. The temperature of the color also affects the mixing possibilities. Mixing a cool blue with a warm red will give a totally different violet than mixing a warm blue with a warm red. In colored pencils, Prismacolor's Poppy Red is warm, Crimson Red is cool.

As you see in these next two examples, I have taken the color wheel several steps further.

COMPLETE TERTIARY COLOR WHEEL

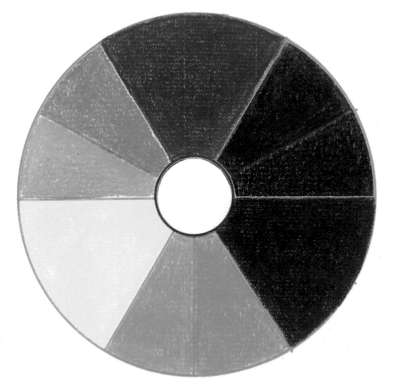

There are six colors on the tertiary color wheel, clockwise from top left: yellow-orange, red-orange, red-violet, blue-violet, blue-green, and yellow green.

TWELVE-COLOR COLOR WHEEL

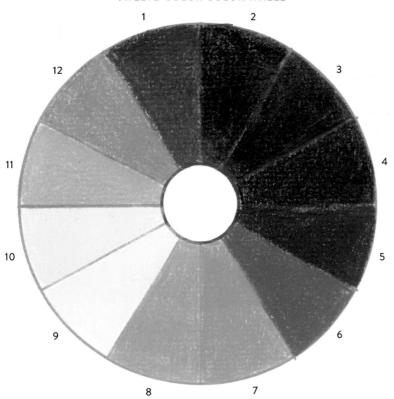

PRISMACOLOR:
1. POPPY RED
2. CRIMSON RED
3. MULBERRY
4. VIOLET
5. ULTRAMARINE BLUE
6. TRUE BLUE
7. TRUE GREEN
8. SPRING GREEN
9. LEMON YELLOW
10. CANARY YELLOW
11. SPANISH ORANGE
12. ORANGE

This color wheel has twelve colors: two reds, two blues, two yellows, two greens, two oranges, and two violets.

COLOR WHEEL WITH VALUE AND SHADE

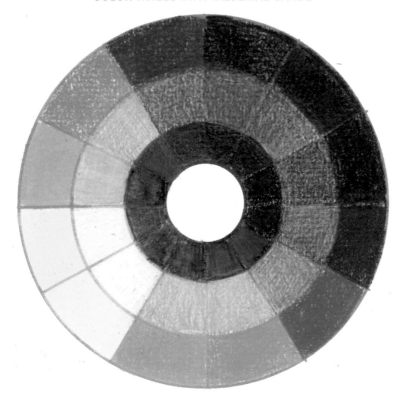

The second layer is value and the third layer is shade. Black is added to the twelve base colors. This is the complete color wheel.

You can use this blank color wheel to create your own. It will be an important reference for you in your work. Remember, a wheel is a circle. It has no beginning and no end. It is continuous. You can mix color forever and get as many variations as grains of sand on all the beaches of the world. That is the beauty of color. The color wheel gives you a base from which to fly.

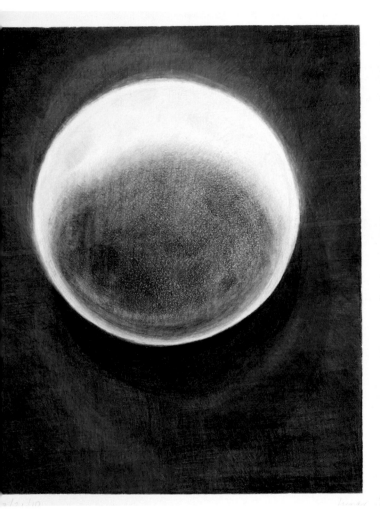
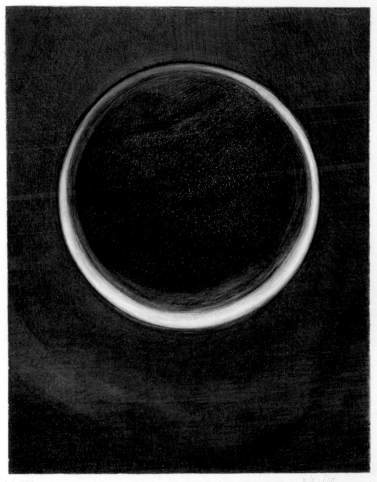

Lisa Dinhofer, *Lunar Eclipse #3*, 2011, colored pencil on paper, 22" × 30" (56 × 76 cm)
Putting objects side by side as a diptych is a composition technique I enjoy exploring. It allows for a conversation between two pieces while each concept retains it own conceptual integrity. Here two different episodes of the moon in eclipse illustrate this point. Around the eclipse what is exciting is that the color becomes prismatic.

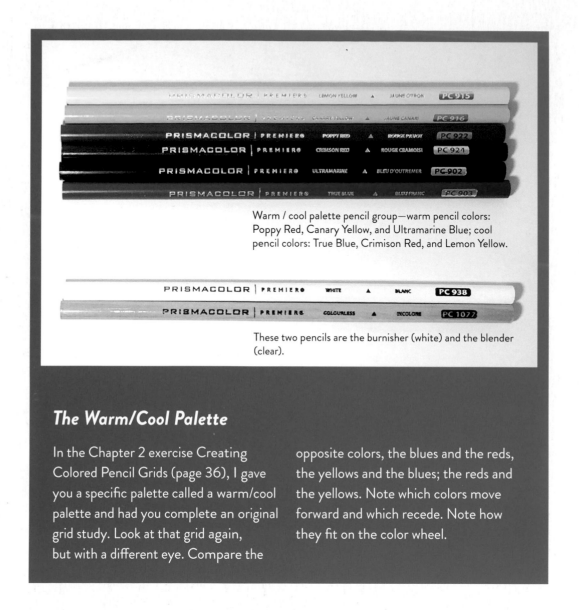

Warm / cool palette pencil group—warm pencil colors: Poppy Red, Canary Yellow, and Ultramarine Blue; cool pencil colors: True Blue, Crimson Red, and Lemon Yellow.

These two pencils are the burnisher (white) and the blender (clear).

The Warm/Cool Palette

In the Chapter 2 exercise Creating Colored Pencil Grids (page 36), I gave you a specific palette called a warm/cool palette and had you complete an original grid study. Look at that grid again, but with a different eye. Compare the opposite colors, the blues and the reds, the yellows and the blues; the reds and the yellows. Note which colors move forward and which recede. Note how they fit on the color wheel.

A COLORING PROJECT

Let's have some fun. I've been intrigued by the recent phenomenon of coloring books. With that in mind, I created this blank pattern (opposite) for you to color. As you see, there are three boxes, each with the same pattern.

In one box use only primary colors, in the second only secondary colors, and in the third only tertiary colors. Play with them, referring to your personal color wheel.

MIXING COLORS

Once you have your colors and your palette, you are ready to play. Very rarely does the color you want come directly and unaltered from the tube of paint or the point of the pencil, which means your ideal colors must be created. You achieve this by combining two or more colors together. You will need to experiment with mixtures till you find the right combination of colors. Now comes the inevitable question, as you stare at your pencils: How do you do this? Here we go...

MIXING 144 COLORS FROM JUST EIGHT PENCILS

This exercise deals solely with mixing colors. I limited the palette to the colors on the palette on page 56.

These are all the colors you need for this exercise. So that you won't be tempted to use any other colors, please put all other colored pencils away, out of sight. The exercise itself will be done on the blank grid on page 61. This grid is called the Mixing Grid and it has twelve boxes across (columns) and twelve boxes down (rows). The grid is complete when all 144 boxes are filled in.

The object of this exercise is to fill each square with a different color, each created using only the eight pencils in front of you. You will need to mix and layer each box. It can be done, as you can see from the two completed grids on page 60, each completed by a different student.

Learning how to mix and layer color is one of the most important elements in creating a successful picture. One of my teachers gave me a very valuable piece of advice. He said, "Learn to mix the color, then if available and if you want to, buy it."

I have taught this assignment many, many times. It is always momentous and revealing when all students' finished grids are hung on the wall, side by side. No two are the same, and each is beautiful, whether it's a class of ten, twenty, or more. Let's see: 144 squares of color × 10 students = 1,440 different squares of color; 20 students = 2,880, and so it goes, on and on. From just those same eight pencils, you can create an infinite amount of color mixtures.

Supplies

- Prismacolor Premier Colors
 - 2 Reds: Poppy Red, Crimson Red
 - 2 Blues: True Blue, Ultramarine Blue
 - 2 Yellows: Canary Yellow, Lemon Yellow
- White pencil
- Blending pencil
- Pencil sharpener

Note: Most students start out with a systematic approach to creating the colors, but toward the end, let's say the last 20 squares, the systems break down and one has to rely purely on the eye. This is the ultimate goal—to *actually see the differences*. This project takes time—on average from three to twelve hours. Remember art is not a race against the clock. However long it takes to complete this project is what it takes.

What I hope you take away from this exercise is to learn the properties of each color so that you can create nuances of color by further mixing. For example, learn to mix various umbers (umber is a brown). Then you can understand the difference between the brown in a Raw Umber and in a Burnt Umber.

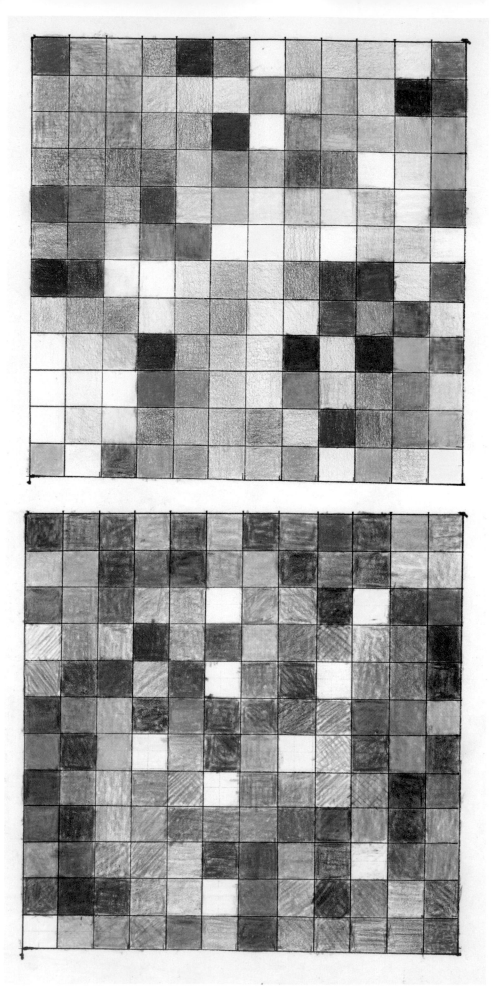

Two different mixing grids created by two different students, who used the same eight pencils you're using. Note how different they are from each other. No two hands are alike; each person's perception of color is different, so different people will always create different grids.

Blank Mixing Grid

COLOR RELATIONSHIPS

"One color is only as good as the color next to it" is the one concept that all my teachers and professors used over and over again. Because drawing and coloring are visual, really seeing and experiencing the color transitions is of critical importance. In the next set of illustrations, I will show how one color changes when placed on four different color fields.

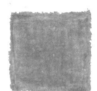

KEY

PRISMACOLOR PREMIER
KEY—LILAC

1. APPLE GREEN
2. JASMINE
3. DIOXAZINE PURPLE HUE
4. SCARLET LAKE

In this color relationship illustration, see how the key (center) color changes and interacts with the four different colors around it. The key color may advance or recede from the surrounding color, or simply ride the surrounding color's surface. Ask yourself why. Now look at your mixing grid and see how each color interacts.

1

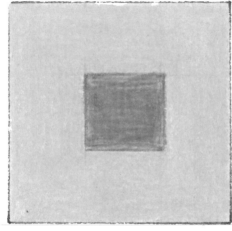

2

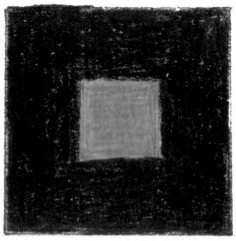

3

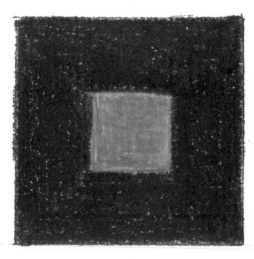

4

COLOR BALANCE

Color balance equals the amount of color used in relation to another color. The size of the area of color that surrounds another color will define the intensity of the interior color. The balance of a color and where it is placed can give a picture its depth.

For example, if a green is surrounded by a violet, the green will come forward because the violet has more balance than the green as it covers more area. If the violet is surrounded by the green, the green will recede because it has more balance due to its greater area of coverage.

Here are four grids that illustrate color balance, each colored with these four Prismacolor Premier pencils: Raspberry, Light Green, Parma Violet, and China Blue.

The same four colors (left) were used in each of these four illustrations. You can see how the relative balance of each color is influenced by the color next to it.

PRISMACOLOR PREMIER

1. PARMA VIOLET
2. LIGHT GREEN
3. RASPBERRY
4. CHINA BLUE

COLOR BALANCE EXERCISE

I suggest you try a color balance exercise on your own. Choose four colors at random, place each color in the center of a different box, and watch what happens as you surround each color with another. I've provided blank grids and a blank color key for you to use.

COLOR WEIGHT GRID KEY

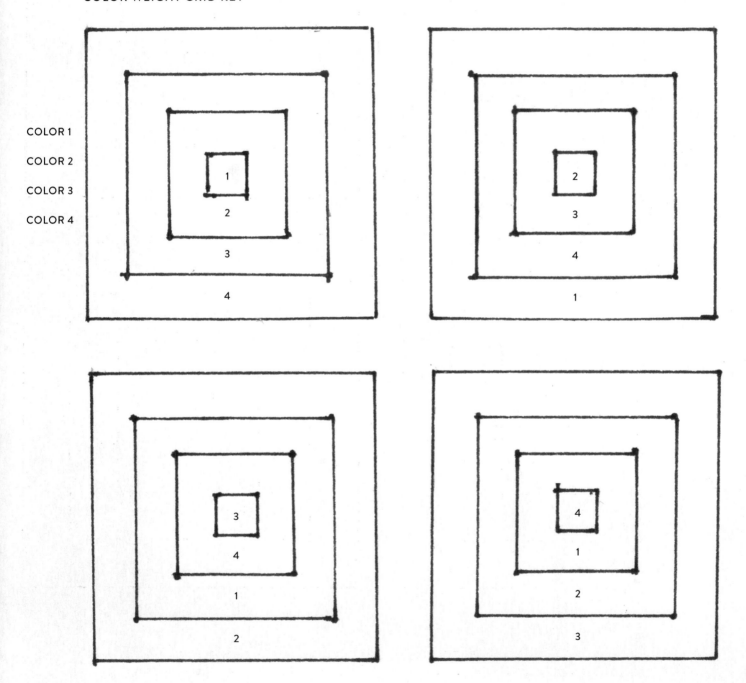

COLOR 1

COLOR 2

COLOR 3

COLOR 4

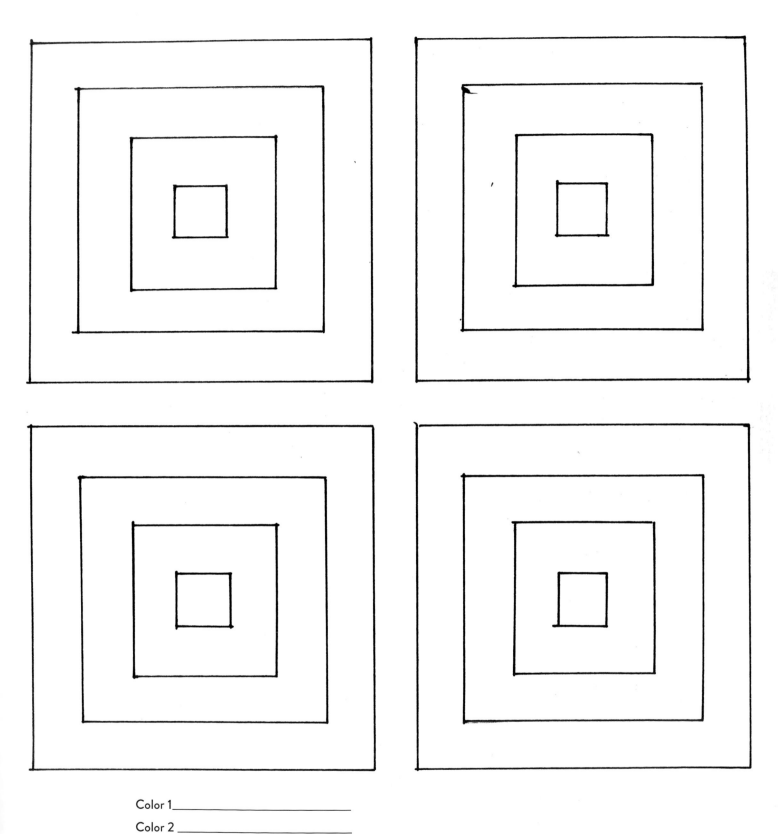

Color 1_____

Color 2 _____

Color 3 _____

Color 4 _____

VALUE VS. BRIGHTNESS

Brightness is how vibrant the color feels. Knowing how to use color to create light and dark will allow you to give any picture an extra dimension. It's important to remember that when you look at color. Color can be used to define value. Displayed (below) is a Value Intensity Scale for the color red that illustrates value versus intensity. On the left of the scale is the value (achieved by adding white or black to the color red). The right side

of the scale uses different colors to create the same effect that the different values of one color can have. Using color instead of black or white to achieve your value effect adds punch to your picture.

Each of the two color illustrations below has two columns: one is the value scale of one color/hue (on the left), and the other is the color intensity scale starting with the same central color scheme.

LEFT Red color intensity scale; **RIGHT** Blue color intensity scale, with values in the left column and brightness in the right column. In the blue hue illustration the "dark" colors descending from the center are not the pure blue mixed with black but mixed with a deep green. In the red hue example the "light" hues ascending from the center pure red are not a mixture of red and white but a mixture of red with yellow orange. By using color as a value, your picture will resonate with vitality. Again color is magic.

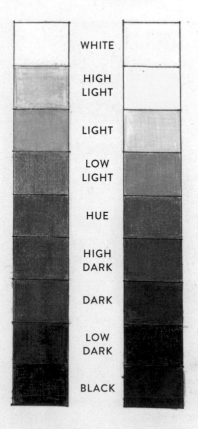

VALUE / INTENSITY GRID: WHITE TO BLACK

WHITE

HIGH LIGHT

LIGHT

LOW LIGHT

HUE

HIGH DARK

DARK

LOW DARK

BLACK

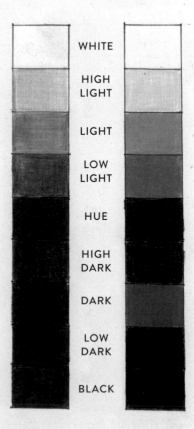

VALUE / INTENSITY GRID: WHITE TO BLACK

WHITE

HIGH LIGHT

LIGHT

LOW LIGHT

HUE

HIGH DARK

DARK

LOW DARK

BLACK

MAKE YOUR OWN VALUE VS. BRIGHTNESS GRID

When looking at the Value vs. Brightness illustration opposite, note how the intensity of color can give similar effects as a value of the color.

Fill in your own grid following the instructions below.

The Value Column is on the left. To color it:

1. Start with the main/pure color (hue) in the center box of the nine boxes (fifth box from the top or the bottom).
2. Color in the four boxes above the center in gradually decreasing intensities of the main color by combining the color with white, using more white pencil in the mix as you move up.
3. Color the four boxes descending from the center in the same manner, except using a black pencil instead of white, getting darker as you move away from the center.

The Brightness Column is on the right. To color it:

1. Start with the same base color you used for the Value Column in the center box of the Brightness Column.
2. Instead of combining the base color with white in the four boxes as you move up, look for light/bright, but non-white color that will create the same effect as white; for instance in the red hue example the "light" is not a mixture of red and white but a yellow-orange.
3. Instead of combining the base color with black in the four boxes descending from the center, look for a dark, but non-black color that will create the same effect as black; in the blue hue example the "dark" is not blue mixed with black but a deep green.

VALUE / INTENSITY GRID:
WHITE TO BLACK

WHITE

HIGH LIGHT

LIGHT

LOW LIGHT

HUE

HIGH DARK

DARK

LOW DARK

BLACK

HOMEWORK ASSIGNMENT #2:
A WARM / COOL STUDY

The homework assignment for this color section is a warm/cool study. Chose one object of interest to you. I suggest a red or green apple, or a green, yellow, or red pear. Keep the form of your object simple and opaque.

This is a perception project. If you choose an apple, place it on a field of one color. There will be two background colors, one on each side of your page, one warm, one cool. The object of this project is to see how your apple changes from one field of color to the other.

Render your object fully including the shadows. Do not change your light source. Just set your still life in the same place for both sides of your page. In all observational assignments that I give my students (excluding the grids), success doesn't necessary come in following the assignment absolutely precisely, as you can see in the difference between Yuka's rendering and Satoko's rendering opposite.

Perception Project Diagram #1. Divide your paper in half. Make your object at least sixty or seventy percent of your picture plane, leaving room for shadows.

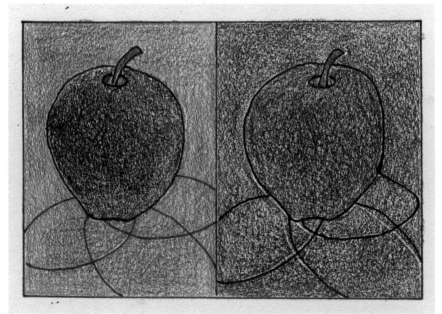

Perception Project Diagram #2

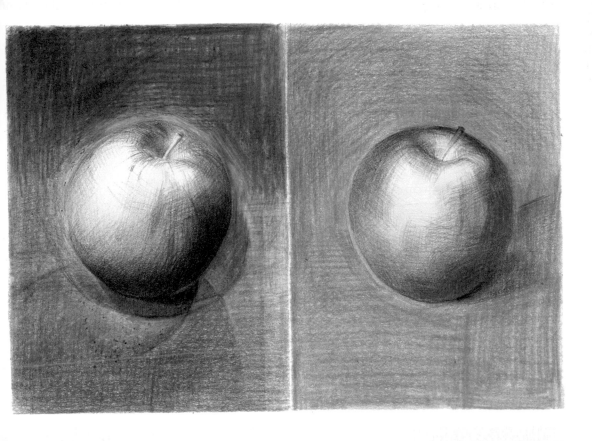

Student Example #1 by Yuka Imata
Success: Yuka's careful rending of the same apple on different colored backgrounds illustrated the changes in the apple from the reflected color of the background that surrounds it.

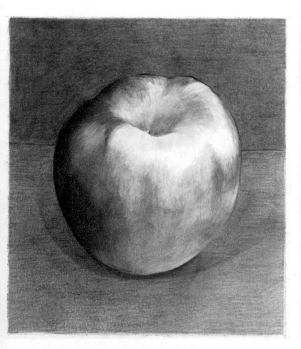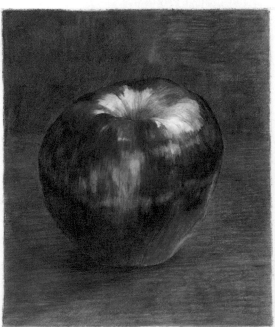

Student Example #2 by Satoko Takahashi
Success: Satoko rendered two different apples. Her choices enhanced the assignment by producing a redder apple in the warm study and a greener apple in the cool study.

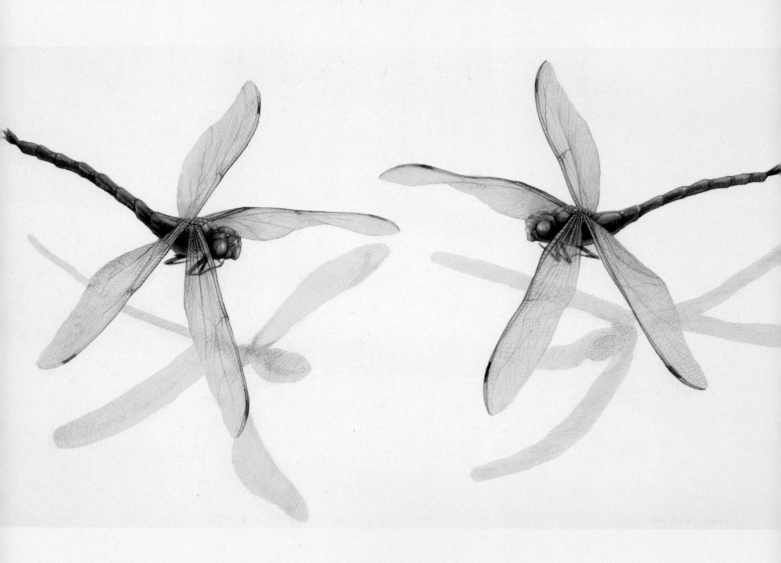

"*Creativity is allowing yourself to make mistakes.*
Art is knowing which ones to keep."

SCOTT ADAMS, CARTOONIST

TECHNIQUES WITH COLORED PENCIL

|||

IN THIS CHAPTER WE WILL EXPLORE A VARIETY OF TECHNIQUES FOR USING YOUR COLORED PENCILS. There are two truly interesting properties of this medium: 1) how forgiving colored pencils are, and 2) how many pencil techniques you can use to enhance an artwork. Artists in all disciplines can and do incorporate colored pencils into their process, and adapt pencil techniques to their needs and knowledge. A painter, whether working in oil, acrylic, or watercolor, might experiment with wax colored pencils and solvents or watercolor pencils and washes. Printmakers can use techniques including embossing, scraping, and stenciling. Sculptors can explore colored pencils on different surfaces. And, of course, all of these techniques are interchangeable and can move from artistic discipline to artistic discipline. Color pencils are indeed a universal medium.

OPPOSITE Lisa Dinhofer, *Two Dragonflies*, 2007, colored pencil on paper, 15" × 27" (38 × 68.5 cm)

WEIGHT OF HAND DEMONSTRATION
PRISMACOLOR VIOLET

ABOVE You can see how as the weight of hand decreases as it moves away from the center the color gets more and more transparent.

LAYERING DEMONSTRATION

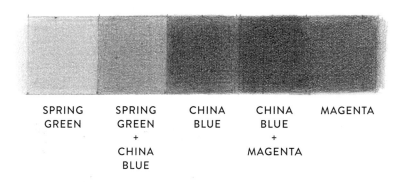

| SPRING GREEN | SPRING GREEN + CHINA BLUE | CHINA BLUE | CHINA BLUE + MAGENTA | MAGENTA |

ABOVE In this layering demonstration, notice that the Spring Green in the first box and China Blue in the third box are put on top of each other to make the second box, which is a variation of blue-green.

TRANSPARENCY

Transparency in drawing and painting allows the white of the under surface (paper or canvas) to come through. Transparency can be achieved in several different ways using colored pencils. Here's how some techniques we covered in earlier chapters can be used to create transparency.

Weight of Hand

The amount of pressure you put on your pencil, from light to hard, will create different effects in the drawing and on the paper. In the Chapter 2 grid (pages 38–39) the different way the pencil was used created a different effect. The lighter the touch, the more transparent the effect. Note the demonstration at top left.

Layering

Layering is the act of putting one color on top of another. In your color mixing grid (page 61), you did some layering (by necessity) without knowing what it was called. I am now putting a name to it.

The lighter your layering touch, the more transparent your color; the heavier your hand, the more opaque it is.

Washes

There are several ways to achieve washes with colored pencils. First is through the type of pencil itself. Watercolor pencils have varying degrees of color intensity. Derwent Inktense Pencils have a very dense pigment concentration, Faber-Castell Albrecht Durer watercolor pencils, Prismacolor watercolor pencils and Caran d'Ache Aquacolor are all good pencils, with less pigment, giving a lighter feeling.

WATERCOLOR PENCIL WASH
WITH WATER

ABOVE Here's how you do a wash with water. Lay down a layer of color with your pencil, then, using water and a brush (or sponge) spread a light layer of water over the colored surface. The more color laid down, the richer the wash, as you can see above.

WAX PENCIL WASH
WITH SOLVENT

ABOVE You can also create a wax pencil wash using solvents. (See page 24 in Chapter 1 for a complete list and information on working with them.) Place a layer of pencil on your page. With a brush, sponge, or cotton swab skim the surface with solvents, creating a wash.

A Few Notes about Washes

I find washes are a good way of covering a large area with one color. But—there is a "But" here—there are drawbacks to each of the wash techniques.

1. There is a limit to the amount of layering that can be applied on top of a wash. Without adding water or solvent you can apply four or five layers, with a wash you may only be able to apply three. More than three layers with a wash, and you probably won't be able to achieve a lot of detail and your pencil will not be able to make the impression you want; it will skim the surface.

2. Washes do not erase efficiently. The wash will stain the paper, making it nearly impossible to correct mistakes.

3. When using a watercolor pencil and water, your paper may buckle. Therefore take precautions. One solution is to tape your paper down to a hard surface such as a drawing board. Another is to use a watercolor block (see page 102).

4. Over time, solvents can destroy your paper if you saturate the paper, so avoid saturating your paper. Solvents can also turn your page yellow and leave a line at the solvent edge.

ERASING

Colored pencils are forgiving. Erasing can easily correct a mistake. Erasers can also be used to create effects.

Basically, an eraser lifts the wax or graphite from the page. A graphite pencil can be erased down to the white of the page. But with colored pencils, no matter how much erasing and rubbing you do, you cannot restore the white of the page. You can get close, especially if there's only a light layer of color.

There are several kinds of erasers and erasing techniques, as detailed below.

KNEADED ERASER DEMONSTRATION

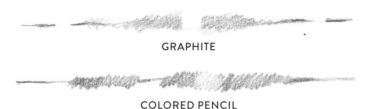

GRAPHITE

COLORED PENCIL

Here are the different kneaded effects you can achieve, with graphite (top) and colored pencil (bottom).

PLASTIC ERASER DEMONSTRATION

RECTANGLE

PEN

Here are examples of the different effects plastic erasers can make. At the top, a rectangular eraser was used; at the bottom, a pen eraser.

Kneaded erasers

Kneaded erasers (photo page 22) can be pulled and molded into any shape, so they can be used on large areas or for small details. They are especially good with graphite pencils.

Kneaded erasers are one of my favorite tools. I think it goes back to my childhood when I played with clay and a toy called Silly Putty. You will find kneaded erasers in different shapes throughout my studio.

Plastic Eraser

A rectangular white plastic eraser (photo page 22) is the eraser to use with colored pencils, wax, and water because using it creates more of a blending process than an erasure. As you keep rubbing, more layers of wax will come off. You can stop at any point. Use the eraser as a blending tool or a corrector.

The plastic eraser also comes as a pen dispenser (photo page 22), which is ideal for small areas and details because it can get into small areas. The pen can be used like a pencil stroke to intensify detail. It can also be used to erase small areas to enhance highlights.

Pumice / Sand Eraser

This rectangular eraser has a pumice-like texture. The pumice eraser can remove large areas of color. It can also go down to the paper. Be careful, though: This eraser can remove the paper and the sizing in the paper. Once the paper is removed a crevice will be left with jagged edges. This crevice will be difficult to conceal.

Erasing with Scotch Magic Tape

You can use Scotch tape to some effect on color pencil, but the tape will remove only the top layer of wax. This is also a difficult tool to control. Remember to use the tape only on the waxy areas. In non-waxy areas, the tape will pull up the paper and perhaps rip it. So caution is the operative word here.

RIGHT This demonstration focuses on erasing part of a pencil drawing. The top panel shows the Scotch tape in place on top of the colored pencil. The middle panel shows the result once the tape is removed. The bottom panel is the Scotch tape itself. You can see how Scotch tape works to erase an area of colored pencil.

PUMICE / SAND ERASER
DEMONSTRATION

ABOVE This a demonstration of how the pumice eraser works. The vertical light areas that interrupt the line of the pencil were achieved by using the pumice eraser.

SCOTCH TAPE →

SCOTCH TAPE →

TAPE DEMONSTRATION

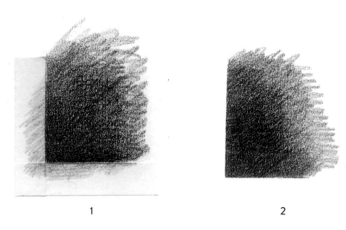

1

2

1. FRAME WITH TAPE ON
2. FRAME WITH TAPE OFF

ABOVE A demonstration of how to create a frame using masking tape. On the left, with tape on; on the right, with tape removed.

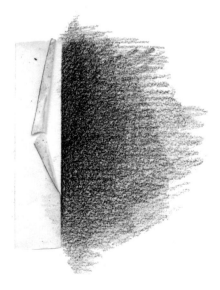

ABOVE To remove the masking tape from the paper, slowly peel it away, one small section at a time, as shown. Slowly, slowly (and carefully) remove your tape. First, while facing the drawing, pull the edge of the tape next to the drawing diagonally away from the surface of the paper. Then, carefully pull up the rest of the tape up and away from the drawing surface.

MASKING

A mask protects the white of the page. Whenever you want to create a highlight, or a frame around your drawing, a masking technique is the go-to method. A mask can also be used to protect one area of your drawing in order to work on another. Basically, all masking techniques prevent the pencil from getting onto the protected area. It keeps the edges clean as well. Once a mask is placed on the page, forget that it is there and work your drawing. Remove the mask and your edge and your highlights remain. After removing the mask, you can return to the masked area to work or rework it.

There are several masking techniques.

Artist Tape or Low-Tack Tape

Tape can be used to frame your drawing. Artist tape (photo page 25) and low tack tape have similar properties. These tapes can be lifted off the paper easily without tearing the paper or removing the pencil stroke. Tapes that have less adhesive, like artist tapes and low-tack tapes, will do little or no damage to your drawing when you remove them, in contrast to Scotch tape, which can damage the paper and remove color. A useful property of tape is that it can be cut to shape to cover and protect an area.

> **NOTE:** *Any tape can be made into a low-tack tape—for example, masking tape or Scotch tape. Place the tape on a dry surface like a table. Press it down, and then lift it up. Some of the glue will remain on the table surface, and you've just made low-tack tape.*

Masking Fluid

Masking fluid (page 25) is used for precision or pinpoint protection of the page—a highlight, for example. Depending on the application, fluid can be used to create a brushstroke quality. Masking fluid is a latex, rubber, or polymer product. If you have any issues with any of these products, check the labels and take precautions.

Masking Film: Frisket

Frisket is a thin plastic film with a light adhesive on one side. It can be cut to any form or shape you desire to protect any area. Using film as a mask allows you to work one part of your drawing at a time without worrying about ruining the areas you are not working on. For example, if you are working on a large piece with a heavily detailed background, you can mask the objects in the foreground and work just the background. Frisket film is very easy to remove; just lift it off the paper.

RIGHT Masking is an important technique, especially if you work on a piece for a long time. Masking is freeing. It frees you to work areas without the worry that you could damage another area. Not only does masking protect areas from a wandering pencil stroke or a meandering wash, but also from the oils from your hands.

FRISKET FILM

1. Frisket file cut to shape.

2. The circle of frisket with colored pencil covering it.

3. The frisket shape of a circle was placed on top of the paper. After completion of the drawing, the circle was removed, revealing the area that had been protected by the frisket.

HOW TO APPLY MASKING FLUID

Masking fluid will destroy brushes, and I don't recommend that you use brushes to apply it. The fluid gets in the hairs and dries quickly; then it is almost impossible to remove. If you do use a brush, always use a very inexpensive or old one that you can throw away.

I recommend you use cotton swabs instead, particularly the makeup cotton swabs designed for eye or nail make-up. They have a pointed tip and tighter weave, so they will hold their shape when dipped into the jar of fluid.

Eye Tees are a brand of makeup cotton swabs that are a great tool for applying masking fluid.

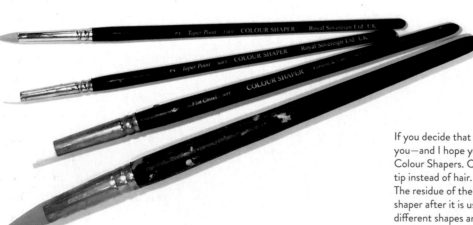

If you decide that colored pencils are the medium for you—and I hope you will—invest in these brush-like tools: Colour Shapers. Colour Shapers are brushes with a rubber tip instead of hair. The rubber tip resists the masking fluid. The residue of the fluid can be pulled off the tip of the shaper after it is used. These rubber brushes also come in different shapes and sizes.

Applying Masking Fluid

Apply a liquid mask by placing the fluid on the area that is in need of protection.

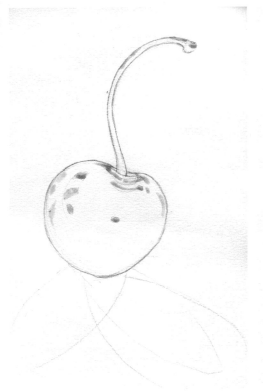

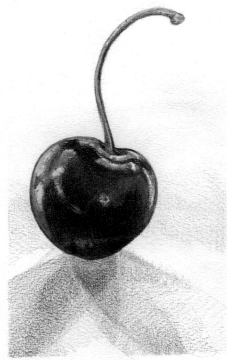

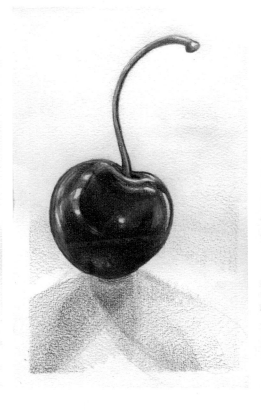

1. The masking fluid should be applied to the highlights after the initial drawing (pencil sketch) is done and the highlighted areas are defined but before the colored pencils are applied.

2. The masking fluid will take some time to dry. It needs to be thoroughly dry before you can work with it. Once the fluid is dry feel free to draw with your colored pencils. Note: The raised pink areas on the cherry are masking fluid protecting the highlights.

3. The finished drawing with highlights exposed after masking fluid is removed. The removal of the masking fluid can be done in several ways.

- Rubbing with a finger will remove the mask. Sometimes rubbing with your finger can leave an oil residue. Be careful not to discolor the area.
- Use a "pick-up." A pick-up is a square of rubber removing rubber cement.
- The third method is with a tweezer. Use the same tweezer used for hair removal. Just pick up the edge of the dried fluid and pull carefully. This method avoids rubbing, resulting in a clean surface.

SGRAFFITO AND SCRAPING

Sgraffito is a scraping technique that reduces the amount of pigment on the paper. Similar to a scratchboard, this technique involves scraping an overlying surface of wax to reveal the underlying one. Note: This technique works best when using a heavier-stock paper (140lb–300lb watercolor paper) with enough sizing to hold several layers of colored pencil. The colored pencil should be wax or oil. The application of the pencil needs to be opaque, so press hard.

Be very careful when using these tools. Always keep the cover of the X-Acto nearby to cover the blade between use. The blade of a straight-edge razor blade can be covered with masking tape or cardboard. Blood is not an art supply.

Sgraffito technique (left) and scraping technique (right). In order to employ this technique a very sharp tool such as an X-Acto knife or straight-edge razor blade is necessary. Scraping is a truly reductive technique and can be used as an eraser. To remove a layer of colored pencil, carefully run the blade across the top of the surface of your drawing. You can also scrape to give raw, scratched texture.

SGRAFFITO DEMO

↑ X-ACTO KNIFE ↑ STRAIGHT-EDGE RAZOR BLADE

SCRAPING DEMO

↑ X-ACTO KNIFE

STENCILING

Stencils are cutout shapes that form clear outlines (or boundaries) that can be used to create a repeating pattern or to highlight a motif.

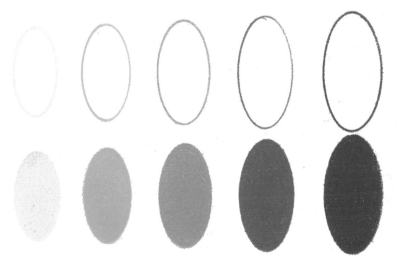

Above is a stencil template with multiple oval shapes in various sizes. Select your oval, position the template in the precise place you want that oval, and fill in the oval, as shown at left.

IMPRESSING

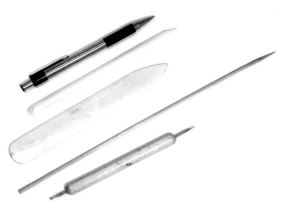

Impressing tools, from top: ballpoint pen (no ink), sculptor's modeling tool, paper folder, chef's skewer, and printmaker's burnisher.

Look at the watermark on a piece of better paper. Run your hand over the mark; some areas are raised and some are not. That is because the mark has been impressed into the paper.

Impressing is a scoring technique. You employ various tools and amounts of hand pressure to impress grooves/lines into paper. Once the groove is made, a color can be placed on top. This color will remain above the impressed line, leaving the impressed/indented grooves and lines clear. You can also use a sharp color pencil to color inside those grooves.

When you color over your impressing, the color stays on the surface, leaving the grooves uncolored.

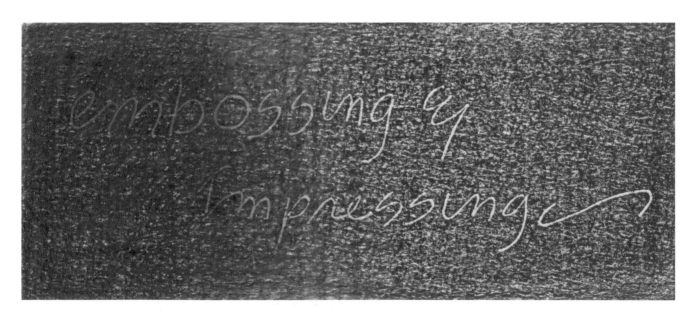

UNDERCOLOR **NO COLOR**

Here's an example of impressing with more than one color. Also notice that I used a very sharp pencil to color in the impressed lines.

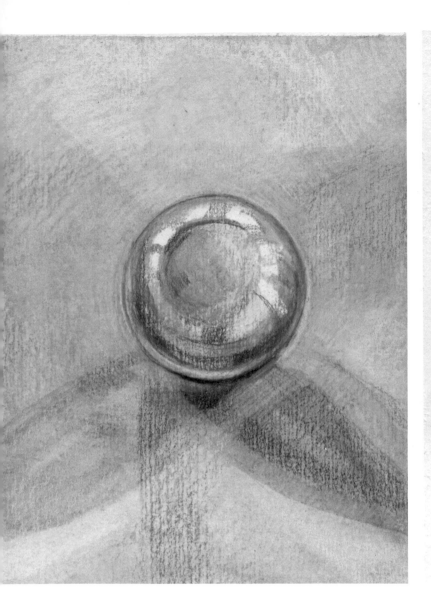
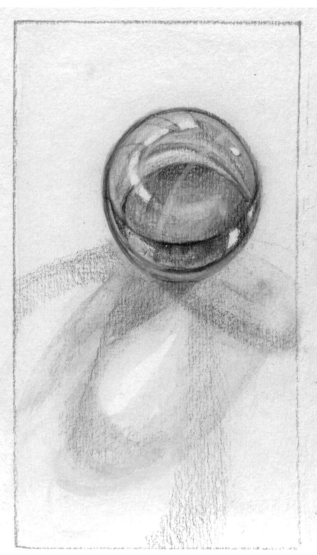

WATERCOLOR AND WAX PENCILS

The one essential to keep in mind when using watercolor and wax pencils together is oil and water don't mix, and neither do wax and watercolor.

The watercolor pencils should be the first layer applied, and the wax pencils then go on top of the watercolor. If you attempt the opposite, the wax first and watercolor second, the watercolor pencil will just skim the surface and the stroke will be lost. If you apply water to the drawing, it will bead up and attach to parts of the drawing not covered by the wax. The water will also leave behind a dull film on the drawing. This technique is very useful when color is needed to cover large areas.

ABOVE Here's an example of the use of watercolor pencils and wax pencils together. At left, the wax pencil, used on top of the watercolor pencil in the blue area, defines the shadow by bringing out the texture of the paper. In the marble without the blue background, at right, the wax pencils allowed me to created more detail in the interior of the marble while the watercolor pencil created the base of the marble.

HIGHLIGHTS: CHINESE WHITE AND ACRYLIC WHITE

First, let me say I do not believe there is cheating in art. Watercolor purists think adding white to a watercolor painting is somehow cheating. Preserving the white of the page is the best and clearest way to the highest highlight. But, sometimes in the process of drawing, the white of the page is lost. Many things can happen, your mind changes, your drawing changes, or a highlight needs to be moved or created in another area. This is where Chinese white and acrylic white come in handy.

Chinese White

Chinese white is a gouache, an opaque medium. When added to a color it will dull the color. The transparency inherent in watercolor will be lost when Chinese white is mixed into the color.

A blue marble with highlights in Chinese white. The Chinese white is floated on top of the already designated highlight.

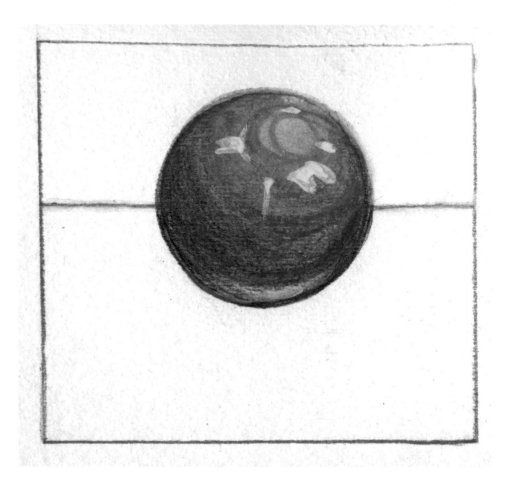

So how do you use it, when, and why?

Chinese white is best used with watercolor pencils. Chinese white should be laid down as a top layer on top of your watercolor layer when your watercolor surface is completely dry. (The amount of time Chinese white takes to dry depends on the amount applied.)

Acrylic White

Acrylic white is the white paint I use with wax pencils. Acrylic paint is a plastic, a polymer. It dries quickly and can be applied very easily, using normal painting techniques. Acrylic paint, like oil paint, comes in different whites with different qualities. Titanium white is slightly warmer than Zinc white. Either will work with color pencils, but it's good to have both on hand. Small tubes are best since this technique is a backup to others. If you have missed a highlight, you can replace it with a dot of this paint. This paint does not mix with the pencils. It will just ride the surface of the wax.

NOTE: *Both these paints, Chinese white and acrylic white, can dull and muddy the color of your pencils. Use them sparingly and carefully.*

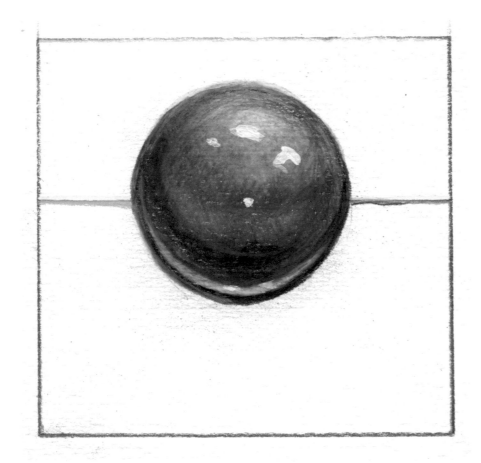

Blue marble #2 with highlights painted in acrylic paint. Just like the Chinese white demonstration, the acrylic white is placed directly on top of the designated highlight.

EXTENDING PENCIL LIFE USING SUPERGLUE

We talked in Chapter 1 about using pencil extenders to extend your smallest nibs into usable pencils and touched on using super-glue to do the same (page 24). Here is a more detailed explanation of how to save the last inches of your used nib by gluing it to the shaft of a new (unused/unsharpened) pencil of the same color. Now we finally get to see how useful Krazy Glue (or Gorilla Glue) is.

1. Identify the pencil. Make sure you are gluing the right color to the right color. (Remember to always sharpen your pencils at the *opposite* end from where the color and ID number are printed.)

2. Note where the identifying name and number of the pencil are. Prepare to glue the bottom of the leftover pencil to the top of the new pencil. The top of the pencil has no writing; toward the bottom are the name and number of the pencil.

3. Put a touch of glue on the top of the shaft. Note: I use the bottle of Krazy Glue that includes a brush for applying the glue.

4. Place the end of the used pencil nib on the glue area.

5. Hold till secure.

6. Place the extended pencil upright in order for the glue to cure for about an hour.

Some Notes:

- The shaft of the new pencil cannot be sharpened.
- The core of the pencil with the circle of pigment exposed must be visible.
- Prismacolor colored pencils are compatible with this method.

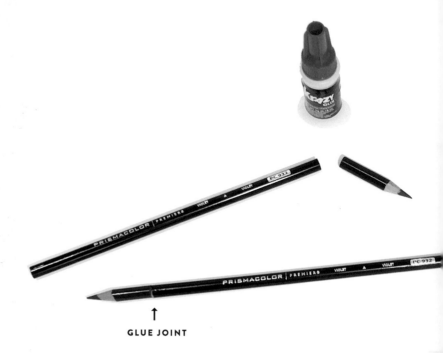

GLUE JOINT

Some Tips:

- Use a fast-drying superglue such as Krazy Glue or Gorilla Glue, *not* epoxy or white glue.
- Make sure the glue is completely dry before sharpening, otherwise the pencil will break at the binding.
- You can only use this method if your pencil pigment is visible at both ends and the ends are flat—this is another reason why I use Prismacolor Premier pencils.
- Scoring the ends you are about to glue can also be helpful but not always necessary.

OPPOSITE: Lisa Dinhofer, *Cicada*, 2006, colored pencil on paper, 9" × 15" (23 × 38cm)
I combined graphite pencil and colored pencil in this drawing. There is no blending or burnishing. I wanted to keep the essence of a pencil drawing.

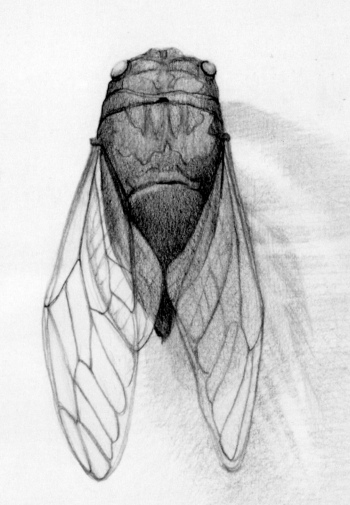

HOMEWORK ASSIGNMENT #3: EXPERIMENTING WITH TECHNIQUES

Finally it is time to experiment. These techniques we covered in this chapter are all pencil oriented and can be applied to all surfaces and papers.

In my classes, after I have described and demonstrated the various techniques discussed in Chapter 4, I ask my students to try each technique individually, and in combination, to hone their abilities and stimulate creative imagination. To expedite this process, I give my students a page with six different areas in which to experiment. Here's one for you.

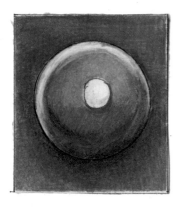

Completed technique assignments from various students. Feel free to be inspired, but try not to copy. Hone your personal vision.

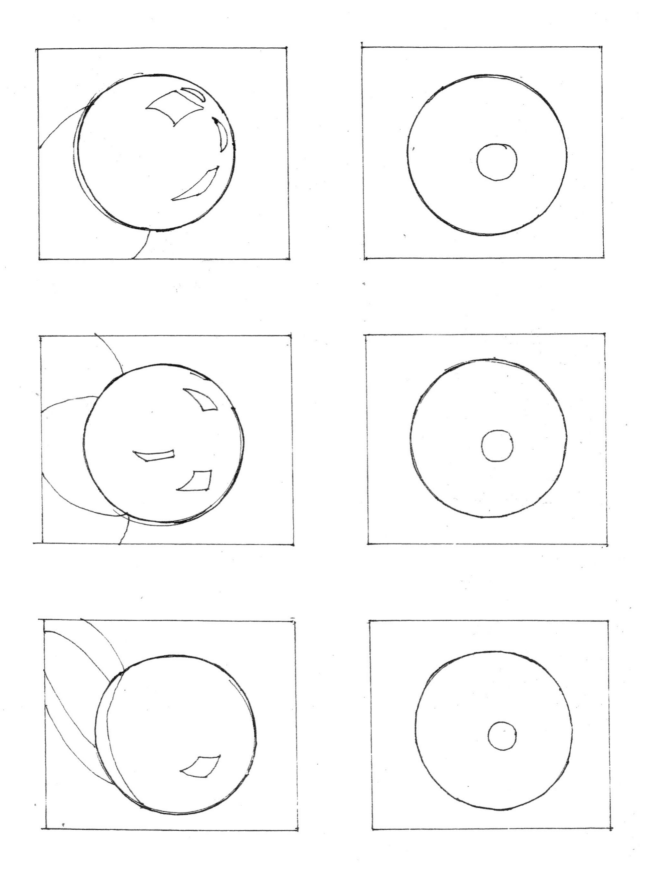

You will be experimenting with maskings, water, solvent, and so on. Some of the grids I provide can be done directly in this book. This one cannot; please copy this sheet on a separate piece of paper, and then proceed.

"*Be who you are and say what you feel because those who mind
don't matter and those who matter don't mind.*"

DR. SEUSS, WRITER, ILLUSTRATOR

PAPER

|||

FORGIVE ME IF I'M BEING REDUNDANT, but paper is a most important component of a successful color pencil work. It is the partnership between the pencil, colored or not, and the paper that creates the drawing. That's why I'm devoting an entire chapter to this topic.

The properties and varieties of paper were discussed earlier (pages 19–21).

Paper is a very personal choice. After much experimentation I confidently recommend certain papers for certain projects throughout this book. These are just guidelines, what works best for me. I do suggest you find your own favorites. Try the ones I suggest first, and then go back to the art store and experiment.

OPPOSITE Lisa Dinhofer, *Lady Slipper Orchid*, 2010, colored pencil on paper, 30" × 22" (76 × 56 cm)
Please look to the shadows in this piece. I worked the shadows in this drawing by layering several colors on top of one another. While the orchid itself is heavily worked with blending, in the shadows I left the texture of the page in order to differentiate the object from the ground.

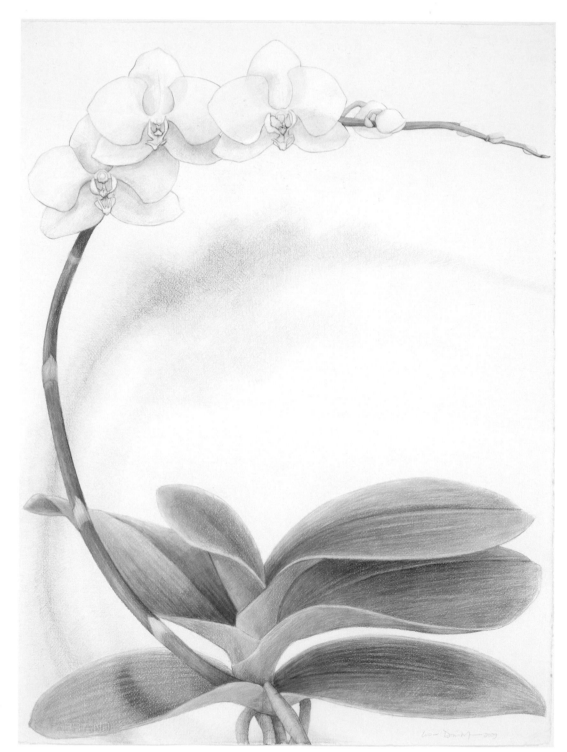

Remember, the weight, texture, and content of the paper matter. The better the paper, the more resilient and longer you can work on it. When starting any new medium, go for a paper that is not expensive, a bristol for example. When this medium of colored pencils seduces you, which I hope it will, make the investment in a beautiful paper. Once you make that purchase, forget the cost and go for your drawing.

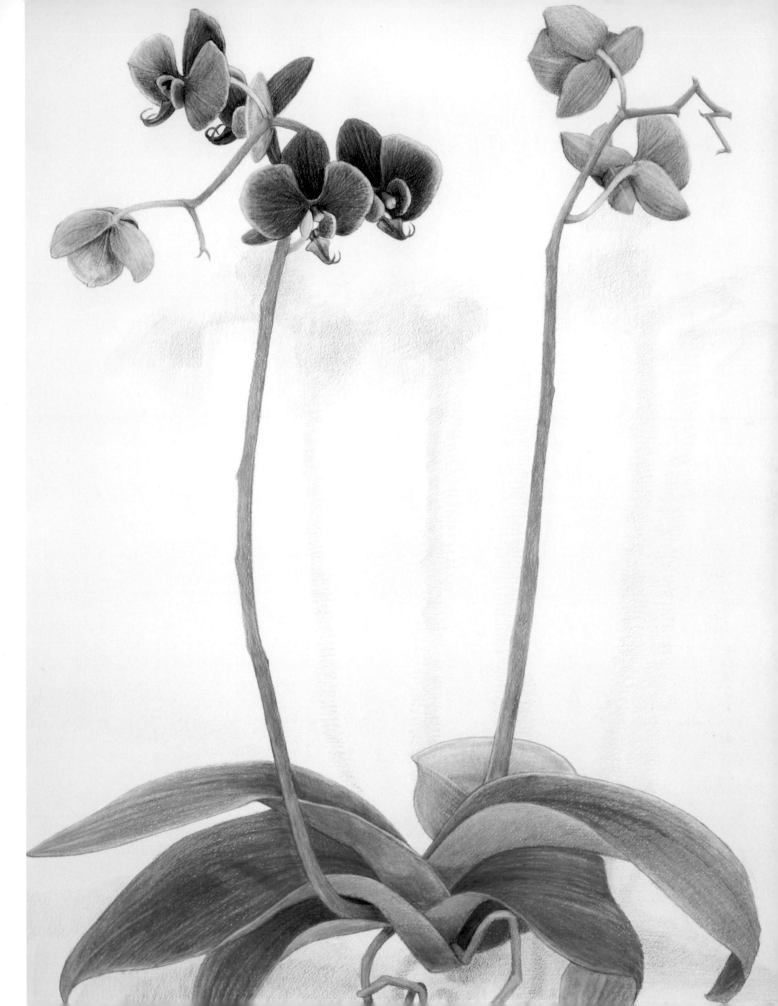

TEXTURE: ROUGH VS. SMOOTH

The texture of your paper, whether rough or smooth, can determine particular effects including transparency, line definition, and color intensity.

Rough papers have a textured surface and can also have less sizing than papers with smooth texture. Your pencil will pick up the texture of a rough paper. Rough surfaces are good for drawings where texture is a necessary element such as expressionistic or gestural drawings. Impressing is one technique that works well with a rougher textural surface.

Smooth papers have little or no surface texture and usually have more sizing than rough papers. Smooth papers are good for precision drawings. Solvents work well on smoother papers. This is the surface I usually chose for my color pencil work.

Both rough and smooth papers take layering, burnishing, and erasing very well.

You can see the smooth texture of the paper through the pencil strokes. Note how the dense color in the center covers the paper.

The rough surface of this paper is very apparent, even in the center where the color is most concentrated.

COLOR PAPER

Color papers can add another dimension to a drawing. There is a natural affinity between color paper and color pencil because color paper and color pencil form a partnership to bring forth intensity and value in your work. The same qualities you look for in a white sheet of paper are just as important in a color paper—weight, content, and texture are all essential in choosing a color paper.

The color, of course, is another variable. A middle-tone paper is the best for color pencils. What is a middle-tone paper? A middle tone paper is one where the color of the paper falls in the *middle range* of a value scale, such as a gray paper. The color range of color papers runs the spectrum from warm to cool. There is a painting technique called "working with grisaille" in which the entire canvas is covered with either a sepia or a gray paint. The painter then works the surface by simultaneously going from light to dark. For example, if you are painting an apple, you can

Lisa Dinhofer, *Manhattan Moth*, 2015, colored pencil on paper, 16" × 20" (40.5 × 51 cm) I designed this drawing as if the two moths were in conversation with each other.

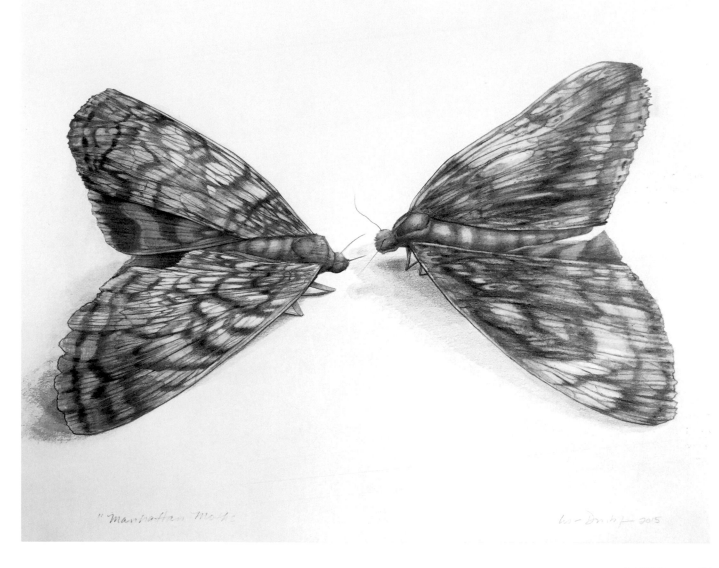

"Manhattan Moth" L. Dinhofer 2015

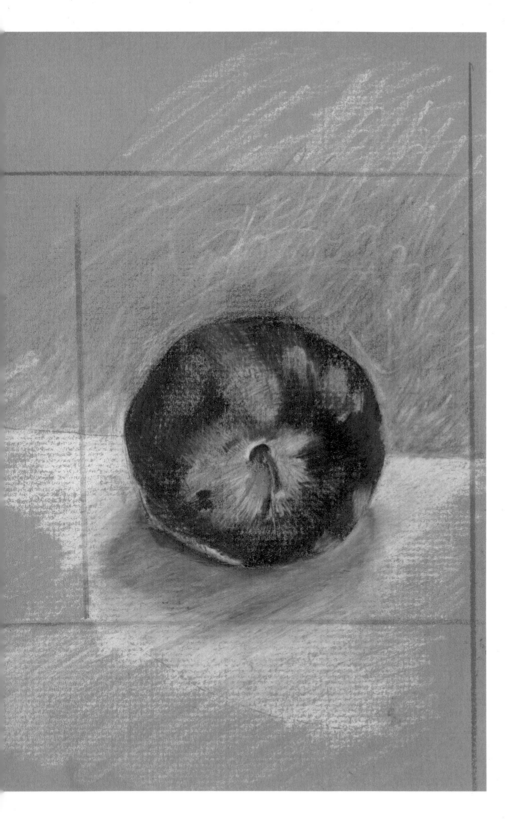

work the shadow and the high-light at the same time to create the feeling of volume.

We use a similar approach to grisaille when working with colored pencils and middle-tone papers. Choose a pastel or char-coal paper in a color/tone you are comfortable with, like a blue, pink, beige, or gray. The color of the paper should be neutral with a grayed tone. (I do not recom-mend color papers that have a bright coloration. A bright col-oration will dominate your page and interfere with your drawing. Bright color papers will just get in the way.) When you have a colored paper as your base, you have a choice of leaving the paper color or covering the surface of the paper with another color.

Apple on middle-tone beige paper, home-work assignment by Mew Chiu
Mew allowed the middle-tone color of the page to come through in the background of the apple and then densely colored the apple to bring out the detail.

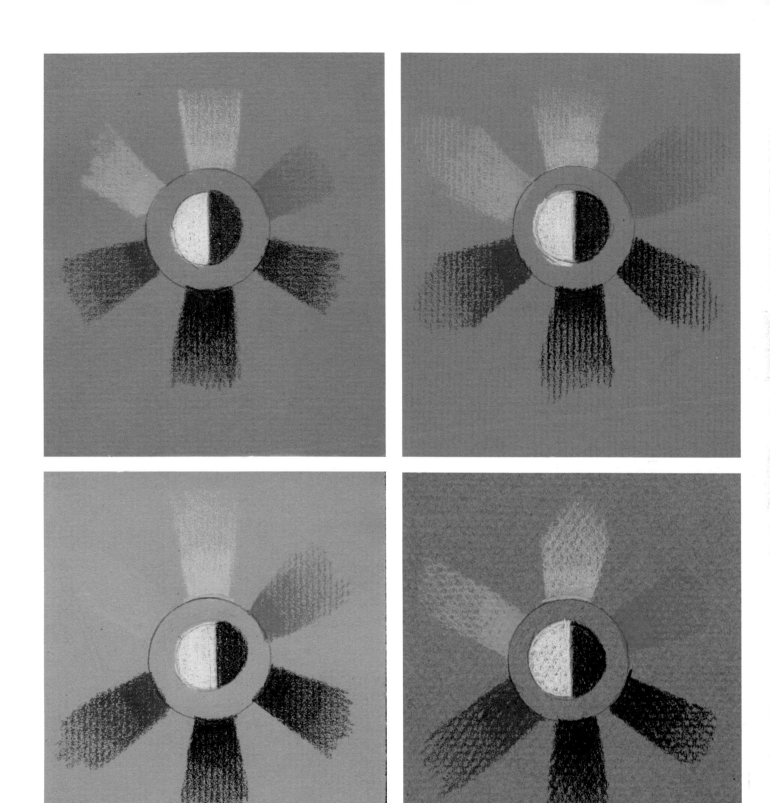

These demonstrations shows how the same six color pencils look on
four different middle-tone papers. Look at one color, for example
the yellow, and see how it changes from paper to paper.

BLACK PAPER

Color pencil also has an affinity for black papers. Of course black paper is the opposite of a white paper, therefore, while a white pencil will act as a burnisher on a white paper, a black pencil will do the same on a black paper. I have worked on black papers quite a bit, and I recommend paper with the same properties as a white paper: hot press, 140 pound,

100% cotton/rag. I suggest Arches Cover, a printmaking paper, which is available in black, white, and gray.

BELOW The same six pencil colors were used on both the black and white paper. As in the middle-tone paper demonstrations, note the change in the intensity of color from the black paper to the white paper.

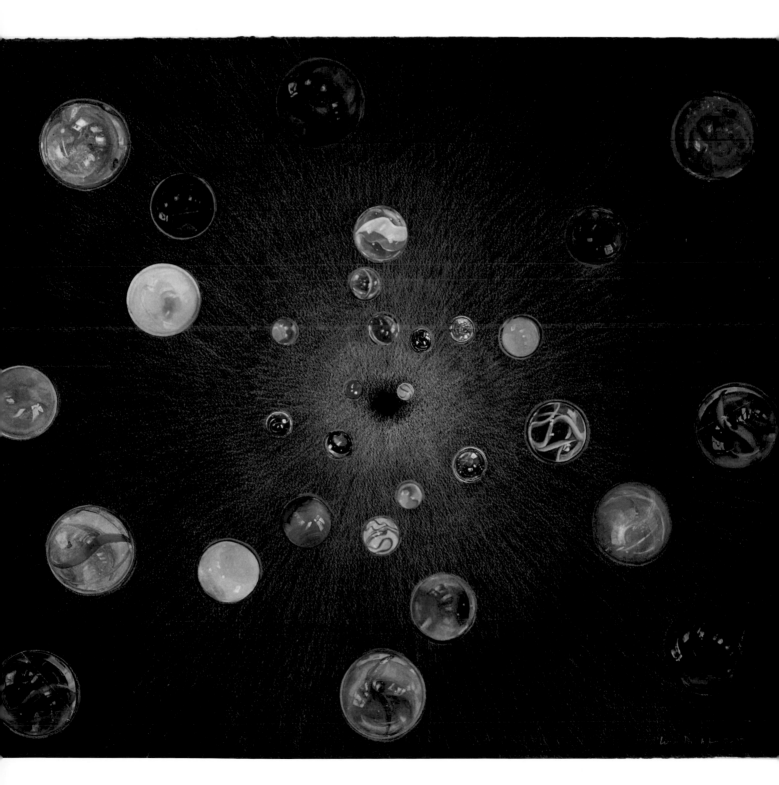

Lisa Dinhofer, *Into the Light Black*, 2004, colored pencil and collage on paper, 19" × 22" (48.3 × 56 cm)

Colored pencils are the base of this drawing. I varied the color of the pencils from cool to warm in order to emphasize the movement toward the center. The marbles are images from my paintings, copied, cut out, and collaged onto the finished colored pencil drawing.

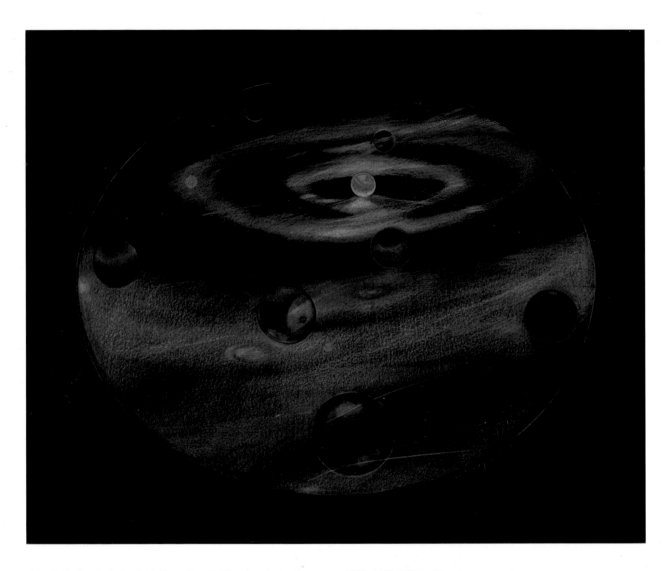

Lisa Dinhofer, *Study for Orbit Fantasies*, 2008, colored pencil on paper, 19½" × 24" (49.5 × 61 cm)

> TIP: In technical terms the most important discovery of working with black papers, as illustrated by the two drawings opposite and above, is the use of the black pencil—it became the burnisher. I consequently found that the color of the paper dictated that a pencil of the same color become the burnisher, a blue pencil for blue paper, and black for black. The colorless blending pencil remains effective with all paper colors.

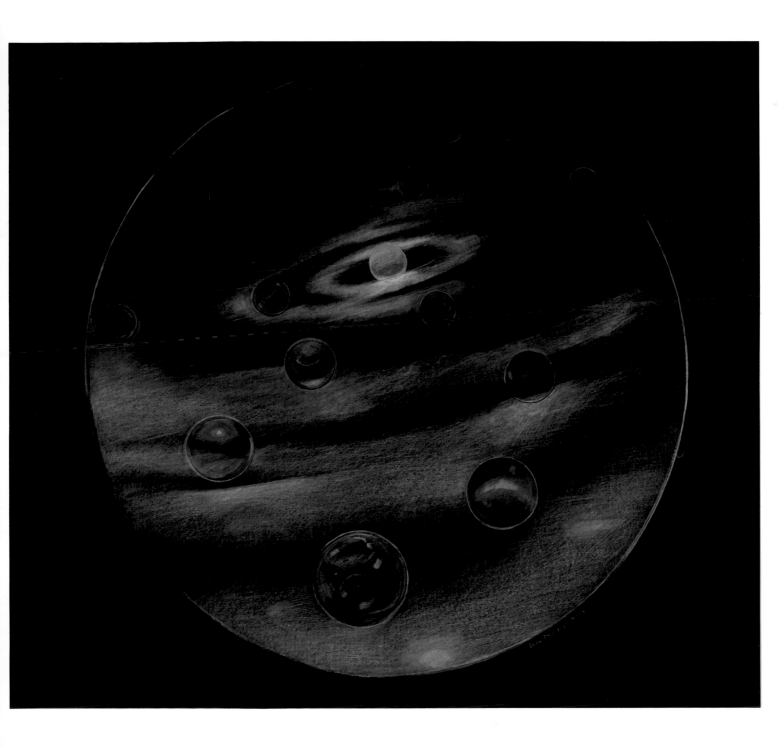

Lisa Dinhofer, *Study for Space Dreams*, 2008, colored pencil on paper, 22½" × 25"
(57 × 63.5 cm)

WATERCOLOR BLOCKS

A watercolor block is basically a stack of good watercolor paper cut to uniform size. The paper is then attached to a dense cardboard backing. All four edges of each sheet are glued to the edges of the sheet under it with a padding glue. (Padding glue is like a vinyl tape that surrounds the block of paper.)

A watercolor block is the best material for watercolor pencils because using a block eliminates the need for stretching the paper. When paper is wet it naturally buckles. Because the stack of papers in a block are already glued to a stable surface, when the wash dries the paper will return to a flat state.

Once the drawing is finished how do you remove one page while leaving the next intact and ready for use? This is the most commonly asked question from my students.

There is an opening on one of the glued sides on all blocks, although the placement of the opening varies from company to company. Arches watercolor block, for example, places the opening at the top of the block in the middle, while Fabriano's opening is on the upper right-hand corner. To remove a page place a flat blunt instrument, like a clean palette knife or a butter knife, between the top sheet of paper and the one under it at the opening. Run the instrument around the edges of the block. This will separate the top sheet from the one under it. Do not use a sharp knife or razor blade. You do not want to cut the next page in the block. Also, make sure the tool you use is completely clean. You want to make sure the next page is ready for your next drawing without any cuts or marks.

BELOW Here's a typical watercolor block. Note that the blunt butter knife is inserted to separate the top page from the stack.

OPPOSITE Lisa Dinhofer, *Flying Bat*, 2011, colored pencil, 30" × 22" (76 × 56 cm) Please note in the *Flying Bat*, the shadows are toward the bottom of the page. This composition indicates the sense of flight.

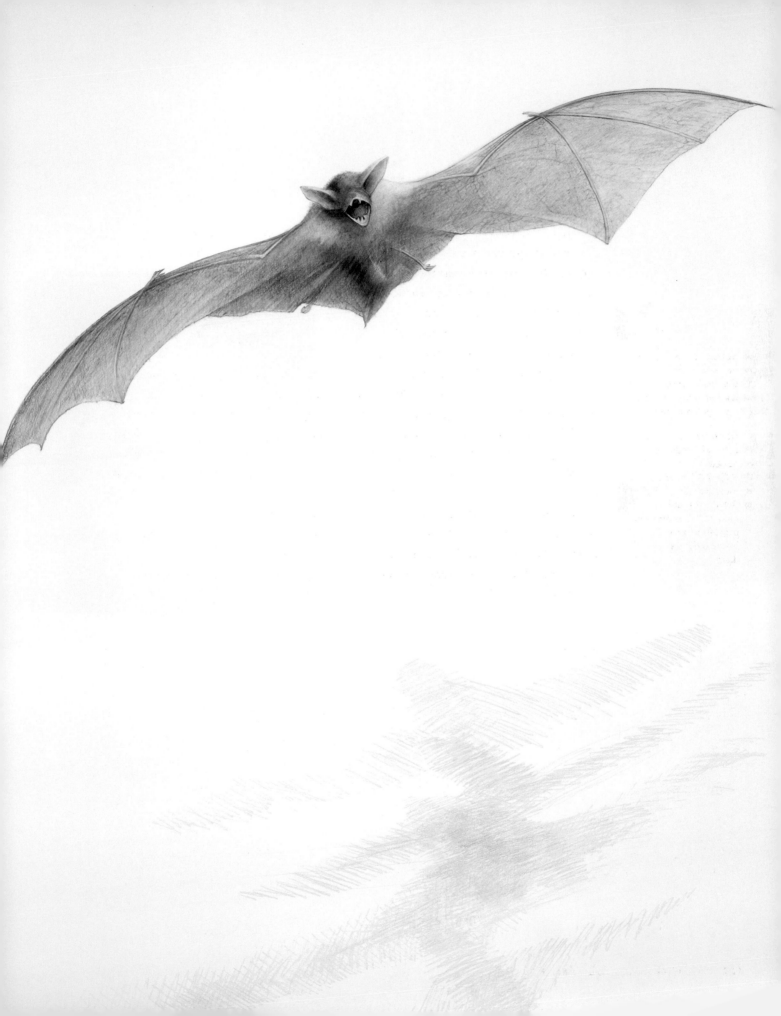

SKETCHBOOKS AND DRAWING BOOKS

Every artist needs a sketchbook or drawing book. They are portable, allowing you to always have a drawing surface with you any time you get inspired.

Sketchbooks

I cannot emphasize enough how important I find sketchbooks to be. A sketchbook can become a drawing journal, a travel diary, a notebook, a project within itself, or simply a sketchbook. An artist I know keeps a dream diary sketchbook next to her bed. Another numbers his sketchbooks, which are filled with ideas for sculptures he's working on as well as ideas for future pieces. He's up to book number 89, which he also keeps by his bed.

My sketchbooks are varied in size and theme. I have a small book that is with me wherever I go, and I also keep several books for large individual projects.

One of the unique aspects of color pencils is their portability. They travel anywhere and make color sketching easy. Go out on an outing or record an errant thought that comes to mind—all you need is a sketchbook and a filled pencil case (which unlike markers, don't leak!).

Drawing Books

I distinguish between sketchbooks and what I call drawing books because I divide my work into two categories—rougher sketches to

ABOVE Here is one of my drawing books, 15¼" × 13½". I have another drawing book that is 15" × 26". You can see some spreads from that book opposite.

OPPOSITE Here are two spreads from my drawing book, from top: dragonfly study, and light traveler's study. These drawings illustrate how I use my books to explore a subject and how they guide me in my approach to the larger work. I draw two different views of the same object, then choose one of the views as the model for the complicated, refined larger drawing, a 22" × 30" large colored pencil piece, reproduced on the facing page.

"If people knew how hard I worked to get my mastery,
it wouldn't seem so wonderful at all."
MICHELANGELO, SCULPTOR

HOMEWORK ASSIGNMENTS

|||

AS I MENTIONED EARLIER, YES, I GIVE HOMEWORK.
Homework reinforces the lessons of the day, and enhances independent creative exploration on the part of any student. The following were all homework assignments from my students. It is critical for all students to learn how to work on their own, how to set up a space that accommodates their personal needs, and how to organize their time.

These assignments are thematic. I pose a question or give a direction as a starting point. The rest is up to the student; it's all about the personal vision.

With all my homework assignments, I try to stay away from the predictable. In this chapter, I give seven different homework assignments for you to try. Accompanying each assignment are examples of how some of my students executed the same assignment and a note from me about why I feel the student achieved her/his goal. Think of this section as extra credit.

Lisa Dinhofer, *Moth March*, 2012, colored pencil, 22" × 30" (56 × 76 cm)
I am intrigued by most animals that fly. I found a box of moths that someone once had collected at a flea market. I decided then and there that I would make these animals fly again.

HOMEWORK ASSIGNMENT #4: DRAW ONE FLOWER

The standard beginning still life class assignment is a bouquet of flowers or a bowl of fruit. This assignment is a portrait of one flower. This is not a botanical study. Keep in mind, as with any portrait the subject needs to be incorporated into the context of the page.

ABOVE Edward Zimmerman, 2015, colored pencil, 6½" × 6¾" (16.5 × 17 cm)
Success: Edward Zimmerman chose the bud of a rose and cut off the stem. This choice is intriguing to the viewer because it is unexpected to remove the stem and treat the bud as an entity in and of itself, like a rock or an orange. Note the balance of color between the yellow-green of the background and the pink of the flower. He also used purple in the shadows. This use of color makes his drawing dynamic and the object three-dimensional.

RIGHT Connie Vitucci, 2015, colored pencil, 11" × 10" (28 × 25.5 cm)
Success: Connie Vitucci's drawing of a bird of paradise explodes off the page. Note the pattern the leaves create. Making the leaves touch the edges of the picture plane creates the tension and intensity on the page. The layering of the colored pencils gives this image its depth.

HOMEWORK ASSIGNMENT #5: DRAW YOUR SHOES

The only item of apparel that has a definite structure is shoes. Shoes are sculpture. And designers treat them as such. I have known a beautiful shoe to be placed on a pedestal. Your shoes also become a personal portrait—a cast of your foot and therefore a poetic presentation of self.

Edward Zimmerman, 2016, colored pencil, 8" × 12¼" (20 × 31 cm)
Success: Edward Zimmerman decided to confront the viewer with his shoe drawing by placing one shoe head-on, at eye level, weighted low on the page. This compositional choice gives the shoe a monumental quality. He simultaneously humbles the shoe through the subtle quietness of his color choices. Note how the laces lead you through the drawing.

ABOVE, LEFT Connie Vitucci, 2015, colored pencil,
9" × 11" (23 × 28 cm)
Success: A Minion, an iconic cultural figure of this time
or rather this moment, 2017. Connie Vitucci chose this
beloved plastic figure to personalize and immortalize. The
purple in the shadow enhances the yellow of the figure,
while the deeper blue of the wall sets it off visually. She
created the feeling of plastic by burnishing the yellow
with a white pencil.

ABOVE, RIGHT Janice Springer, 2016, colored pencil,
11" × 15" (28 × 38 cm)
Success: Janice Springer chose a Japanese teapot from
her collection. She went for the pattern of shadows cre-
ated when there are several light sources. She varied the
color and stroke of her pencils, so the shadows radiate on
the surface of the page. This gives the teapot weight and
a secure place in its environment.

HOMEWORK ASSIGNMENT #6: A FAVORITE THING

We all have objects that we consider treasures. You can chose
one thing or several for this assignment. Place the object(s) in a
situation that is easily understandable—i.e., on a table or against
a wall—and draw. When you chose an object that you have an
emotional attachment to, you bring that intangible with you.

HOMEWORK ASSIGNMENT #7:
A SELF-PORTRAIT REFLECTED
IN AN OBJECT

This assignment is a twist on the traditional self-portrait. Look around your environment and find something unusual that reflects your image, for example, a spoon, an ice bucket, a marble. Remember that the shape and character of the reflective object itself is as important as your reflection.

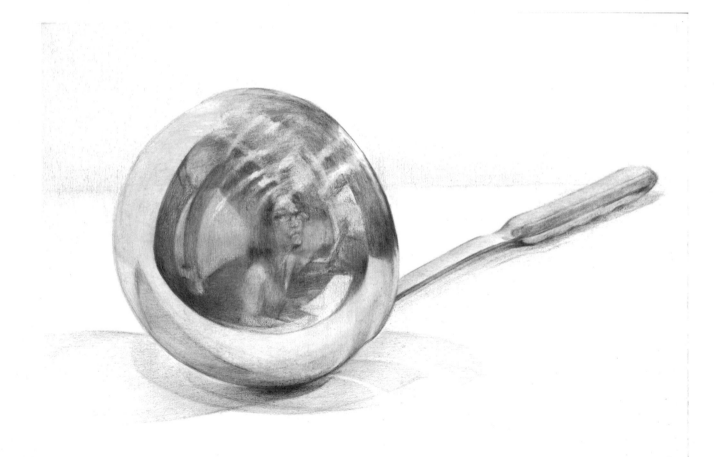

Satoko Takahashi, 2016, colored pencil, 10" × 14" (25.5 × 35.5 cm)
Success: Satoko Takahashi chose a ladle, a very common kitchen utensil. In order to keep the integrity of the object, which included the shape and quality of the metal, she found the highest highlight and emphasized it, even if that meant obscuring part of her portrait. She also carefully observed the distortion of her portrait and portrayed that truthfully.

HOMEWORK ASSIGNMENT #8: REFLECTIONS ON A DINNER PARTY

As the Thanksgiving or New Year's vacation break in my classes approaches, I give this assignment to be done during the holidays. Think outside of the box when approaching this topic. Think of the preparation, the cleanup, the dining room, kitchen, the greeting, eating, socializing, and dress. All of these are aspects of a dinner party.

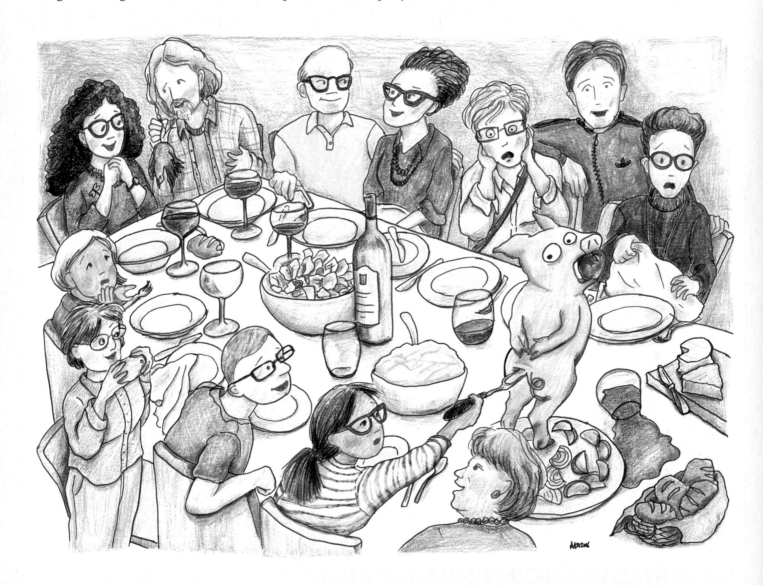

April Tonin, 2016, colored pencil, 8″ × 11″ (20.3 × 28 cm)
Success: I have always encouraged my students to follow their dreams and aspirations. April Tonin is fast becoming an accomplished cartoonist and illustrator. Here she answered the assignment by creating an imaginary dinner party of our drawing class at the National Academy School of Fine Art in New York City. She used colored pencils to enhance the humor of the scene. I am at the head of the table and April is poking the pig.

Edward Zimmerman, 2015, colored pencil, 11″ × 13¼″ (28 × 34 cm)
Success: Edward Zimmerman took a very different point of view of a dinner party. He chose the cork from a champagne bottle and carefully rendered it in color. Note also that in all of the successful homework pieces the background is as carefully thought out and rendered as the object itself, as it is here. It is vitally important to remember that every inch of your picture plane must be engaged.

HOMEWORK ASSIGNMENT #9: HOMAGE

Chose an artist whom you admire and whose work touches you. Study how this artist approaches his/her subject and medium. Why does the work move you? How did he/she do it? Design a piece of your own using what you have learned from analyzing the work of this artist.

Donna Marie Masi, 2014, colored pencil, 14" × 11" (35.5 × 28 cm)
Donna Marie Masi studied the artist Wayne Thiebaud, who has done several pieces featuring spectacles. Picking up on Thiebaud's theme, Donna used her own collection of glasses, carefully observing and rendering the reflections and shadows each object created. A sharpened color pencil allows you to delve into the detail with greater accuracy.

HOMEWORK ASSIGNMENT #10: TOYS

Find a toy that you enjoy and draw.

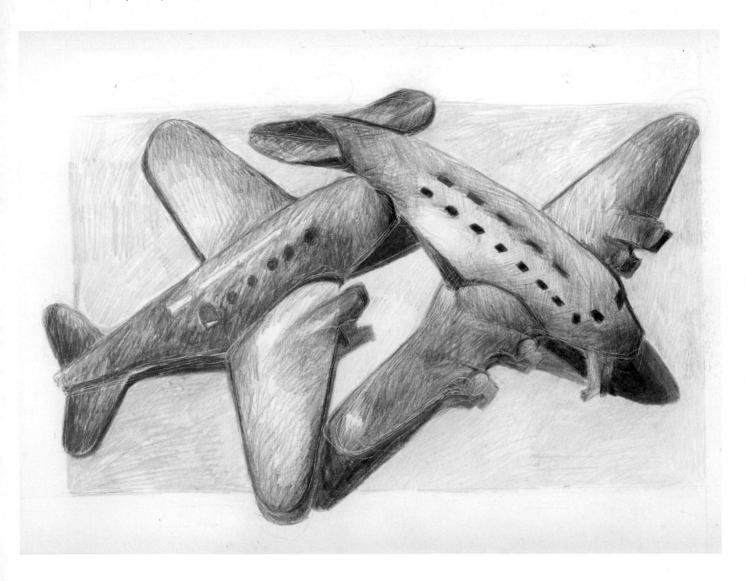

ABOVE Ellen Lauter, 2016, colored pencil, 22″ × 30″ (56 × 76 cm)
Success: Ellen Lauter took her toy airplanes and interlaced them,
as if we had just come upon them on the floor or in the corner of
a room. Note how she varied the outline with color and the weight
of her hand. This not only enhanced the shape of the planes, it also
followed the light.

*"To create one's own world
in any of the arts takes courage."*
GEORGIA O'KEEFFE, PAINTER

THE ART OF THE COLORED PENCIL: AN EXHIBITION

|||

THIS GALLERY OF COLORED PENCIL ARTWORKS is dedicated to the art of colored pencils and the artists who are using them and incorporating this new medium into their extraordinary bodies of work.

How I would have loved to have included works from the icons of classical art—a colored pencil drawing by Leonardo da Vinci, a wax colored pencil by Mary Cassatt, a watercolor pencil painting by Winslow Homer. Unfortunately, colored pencils didn't exist when these legends were working.

Colored pencils are a new medium. The slate is clean for artists of the 21st century and beyond.

For this gallery exhibition, I curated works from eight artists, including myself, from a variety of disciplines including four painters, one painter/sculptor, one sculptor, one graphic artist/musician, and one illustrator. Except for one all are alive and working now.

I asked each artist for a simple statement about how and why they chose colored pencils a medium.

Think of this section of the book as a catalogue for an exhibition. At the end of each artist's exhibition, enjoy brief biographies of each artist.

Lisa Dinhofer, *Luna Moth Pileup*, 2012, colored pencil on paper, 22" × 30" (56 × 76 cm)
The luna moth is beautiful. Each specimen is slightly different. I looked at each moth as an individual, and then placed and drew them as a group swarming.

DOTTY ATTIE

"When I started making lithographs I wanted them to approximate my drawings as closely as possible with certain differences: I wanted to use the medium of print as practically as possible, which meant that I could do certain things with prints that I couldn't do with drawings. My prints could be larger (my drawings were only 2½" × 2½" (6.5 × 6.5 cm), and if I wanted to use the same image many times, I wouldn't have to manually create it again and again. But since I colored my drawings using colored pencils, I decided to do that with my prints, too. That way I wouldn't be limited to only a very few colors, and I would have total control over the tints. It worked out really well, even though I became something of an assembly line worker."

BELOW Dotty Attie, *Sometimes a Traveler / They Lived in Egypt 2036*, hand-colored lithograph, 5⅛" × 5⅛" (13 × 13 cm)

OPPOSITE Dotty Attie, *They Lived in Egypt Composite*, hand-colored lithograph, 23" × 23" (58.5 × 58.5 cm)

WILL

SOMETIMES A TRAVELER

There lived, in Egypt, a man who had a wife renowned for her beauty, and a parrot who, as the occasion required, was his watchman and guard

IN FOREIGN LANDS

Unknown to his wife, the parrot was often the cause of trouble, telling her husband whatever took place in his absence

(WHERE CUSTOMS AND MORES

One night, while the man was away, the parrot observed his wife and her lover disporting together throughout the night

ARE UNFAMILIAR)

When, upon his return, the parrot informed the master of what had occurred, he hastened into his wife's room and punished her roundly

WILL

The maidservant, accused by her mistress, denied responsibility for the betrayal

WHILE HURRYING
THROUGH THE MARKET

She had, however, noticed her master standing for some time in front of the cage, listening to the parrot speak

OR RIDING PAST
THE HIGH WINDOWED WALL
OF THE PALACE GARDENS

Hearing this, the wife resolved to contrive the destruction of the bird

GLIMPSE

A few days later the husband again had to leave his wife for the night

AT THE PERIPHERY OF VISION

Summoning her lover and the maidservant, the three quickly assembled the necessary implements

SOMETHING

Stealing behind the bird, the lover poured water upon a piece of hide onto the parrot's head, while the wife vigorously waved a fan

SO UNEXPECTED

Meanwhile, the maidservant was uncovering and covering a candle hidden under a dish, thus, with her companions, raising a tempest of rain, wind, and lightening

SO UNIMAGINED

The parrot was drenched and half drowned in the deluge

OR HEAR A SOUND

The next day, when the parrot described the terrible storm of the preceding evening, the husband was aghast

SO LOW

"Bird," he cried "you are mad! When was there, even in a dream, rain or lightening last night?"

SO POIGNANT

"You have utterly ruined my family! Your accusations are clearly lies and my wife is the most virtuous woman in the town."

THE IMPRESSION NEVER FADES

His wife lowered her eyes and smiled modestly

KEN CARBONE

"I choose to use color pencil primarily as a sketching tool for idea generation. I like the way it adds life and personality to quick gestures and exploratory drawings. In the example shown here I used Derwent Inktense watercolor pencils, which gave me the desired control for drawing plus the washed-out softness of painting."

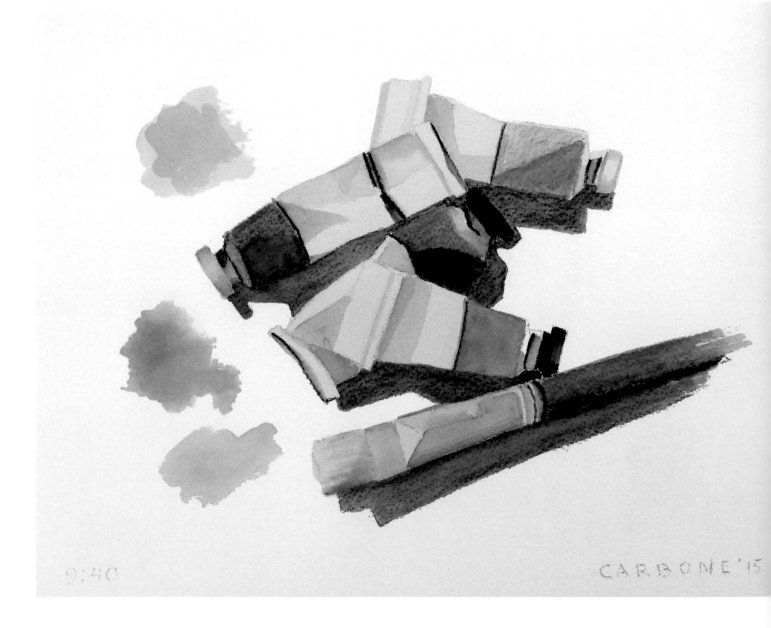

ABOVE Ken Carbone, *9:40-A Day in the Life of Edward Hopper* series, colored pencil, 6" × 9" (15 × 23 cm)

OPPOSITE Ken Carbone, *7:30-A Day in the Life of Edward Hopper* series, colored pencil, 6" × 9" (15 × 23 cm)

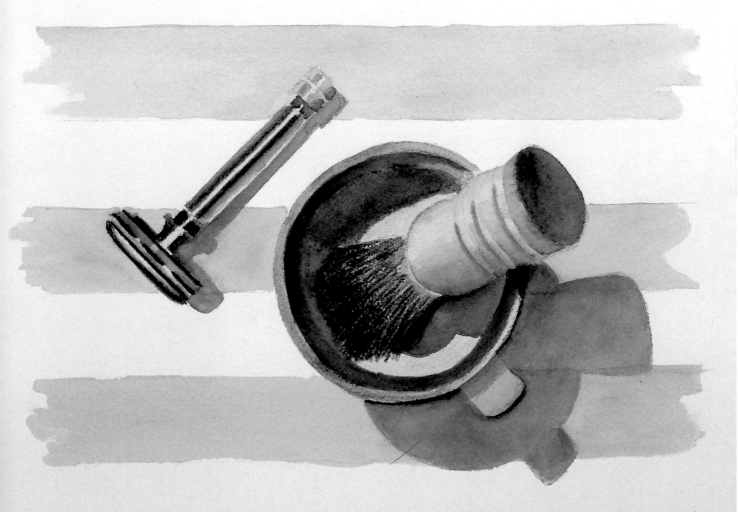

7:30 CARBONE '15

LISA DINHOFER

"Colored pencils have become an extension of my hand and for the last five years my major medium. They have supplanted paint. Just for now."

BELOW Lisa Dinhofer, *Ma on the Beach Between Mars and the Moon*, 2014, colored pencil on paper, 22" × 30" (56 × 76 cm)
This drawing is meant to be a moment in time. It was completed from memory after a quick gesture drawing at the scene.

OPPOSITE Lisa Dinhofer, 2004, *Entering the Web*, colored pencil, 22" × 30" (56 × 76 cm)

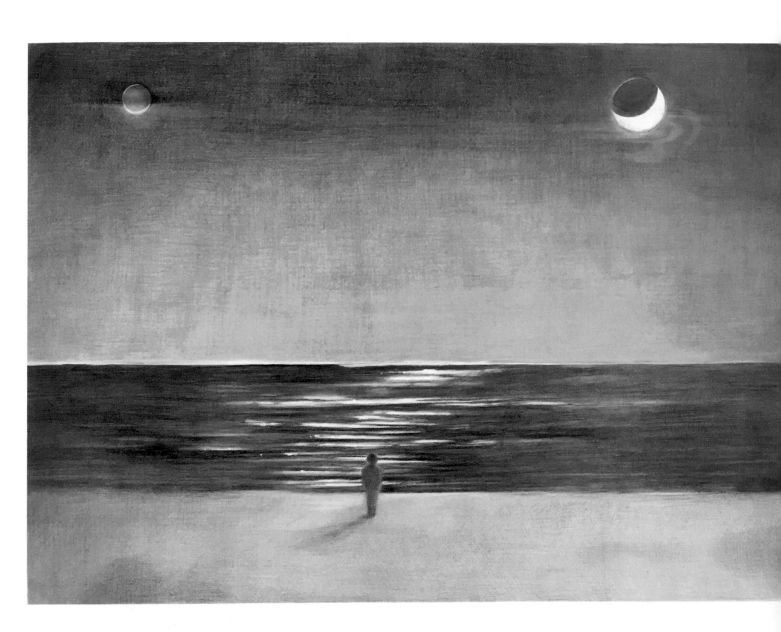

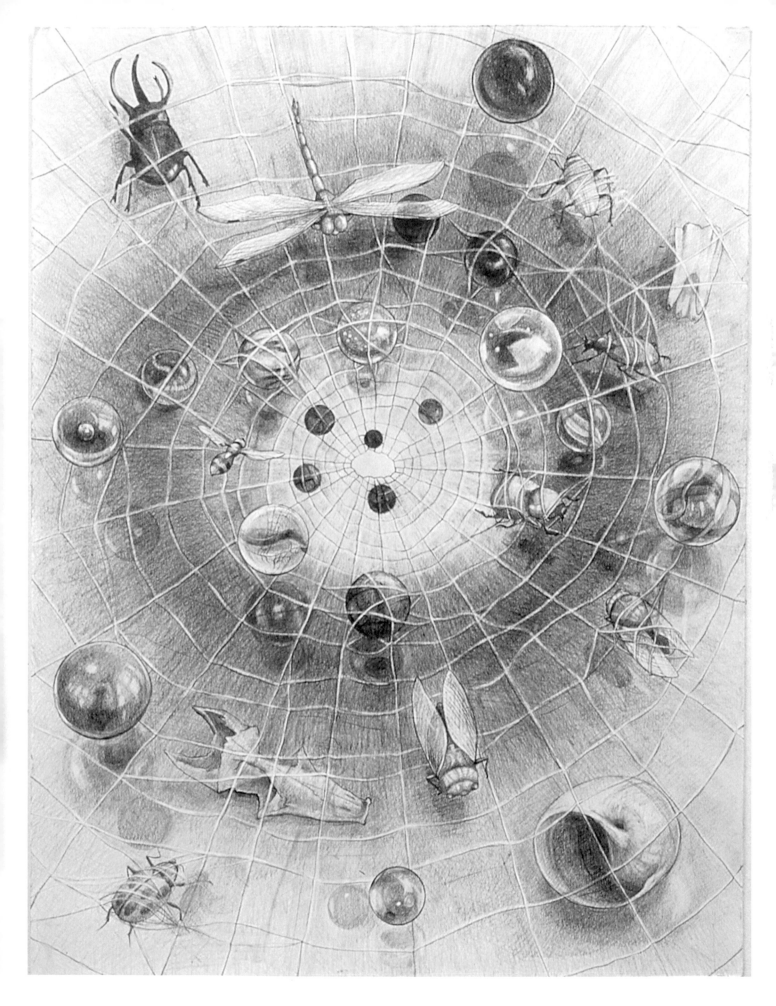

TOM DUNCAN

"My work in color is completely self-taught. When it comes to using color pencils I try to keep it as simple as possible. I don't use a lot of different colored pencils. I use the Prismacolor 48 pencil set. I tend to fill in the color kind of randomly on whatever I have drawn. Then I look at it and assess what needs to be changed. I would say that in general about 80% of my hand coloring works out fine, but the other 20% I will go over sometimes a lot of times, until I get what I want. I glue the drawing to a piece of cardboard and cut out the outline of the figure, then I build up with 5-minute epoxy and multiple layers of white glue. I don't keep a lot of information about color in my head. When I see a color that I would like to use in my artwork I will ask a friend who knows a lot about color how I would achieve that color and she will tell me. It is interesting, we both see colors differently and sometimes argue about that. I think color is a very personal thing."

TURN THIS SLATE OVER

AUDREY FLACK

"Colored pencils are an important part of creating art that could use your exploration and illumination. I have been drawing with Prismacolor, Derwent, etc., with a passion this past year."

OPPOSITE Audrey Flack, *Ancient Carved Wood Statue with Temporal Aromatic Rose*, colored pencil, 30" × 40" (76× 101.5 cm)

ABOVE Audrey Flack, *Terrified & Terrifying: Charles LeBrun and Willem de Kooning*, colored pencil, 30" × 40" (76 × 101.5 cm)

DAN GHENO

"My figurative work is primarily metaphorical, dealing with social, psychological, and political themes, along with formal aesthetic concerns like canvas surface, paint quality, and gestural expressiveness.

"I draw a lot, but rarely as prep work for my painted endeavors. Instead, I'm interested in the practice for its own sake as a stand-alone pursuit, generally concerned with the gesture and form of the human figure. I often choose to use colored pencils as a mono-chrome drawing instrument when working with the human figure, and particularly when working in a linear manner. It's a versatile medium, allowing for delicate, thin lines when I want to indicate a soft or receding form, and bolder more calligraphic lines when I want to suggest advancing or hard forms. On occasion I vary the color of my lines as I work, allowing the multiple hues to serve as a kind of arche-ology layering, revealing the history of the drawing's evolution and my thought processes through the color changes.

"Colored pencils are a great value-massing tool as well. Because of their waxy nature, it's necessary to build up dark tones slowly, by layering glazes of value gradually one on top of another until the desired darkness is reached in a gratifyingly repetitive, almost meditative process."

ABOVE Dan Gheno, *Untitled*, colored pencil, 10" × 18" (25.5 × 45.75 cm)

OPPOSITE Dan Gheno, *Seated Woman*, colored pencil, 24" × 18" (61 × 45.75 cm)

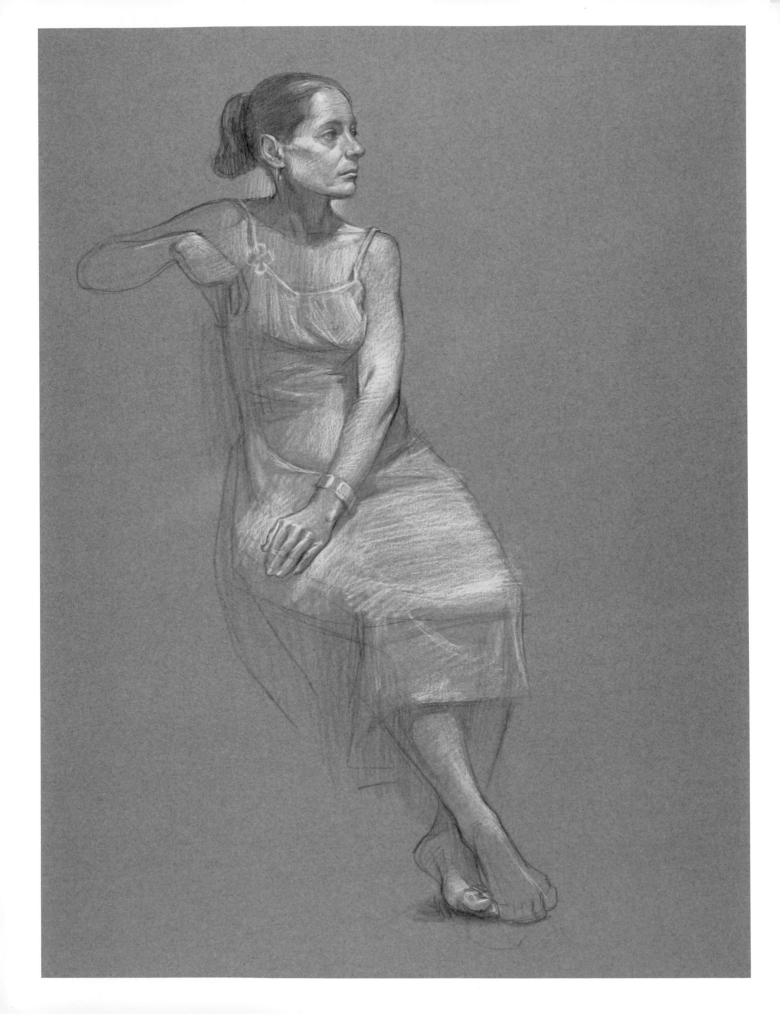

FRED MARCELLINO

As Fred Marcellino embarked on his first picture book, *Puss in Boots*, his primary artistic goal was to explore perspective techniques developed during the Italian Renaissance. In addition, he hoped to accurately depict the elaborate designs from the same era, in fabrics, carpets, clothes, etc. All of these details would require a great deal of precision.

For that reason, the medium he selected was the colored pencil. It allowed him to achieve the full range of rich tone and hue he sought while simultaneously affording accuracy.

BELOW Fred Marcellino, *Tin Soldier Jack in Box*, 1992, colored pencil, 7½" × 9" (26 × 18.5 cm)

OPPOSITE Fred Marcellino, *Puss and Ogre at Table*, 1990, colored pencil, 10¼" × 7¼" (18.5 × 23 cm)

COSTA VAVAGIAKIS

"Drawing always played a prominent role in my life and remains an integral part of my process. I do countless drawings as I set out the concept for a painting; I also do highly realized drawings as ends in themselves. I draw from life—from direct observation and from experience. These drawings are a by-product of each experience, and the eventual concept of a painting is a synthesis of all of these drawing experiences. I do dozens of drawings of the same sitter; drawing is more than simply a preparatory tool. It is a way of becoming intimate with my sitter. I do drawing after drawing of very similar poses, exploring subtle shifts of axis and mood in the model. I place the sitter against a white wall and illuminate him or her with a light from above, to accentuate the volumetric dimensionality of the form. I want the viewer to have the sensation of encountering a real person. Sometimes when drawing from a model in graphite or chalk I respond to the color that I see and turn to colored pencils to continue the drawings. These drawing are some examples of this process."

BELOW Costa Vavagiakis, *Connie XVI*, colored pencil, 15" × 19½" (38 × 48 cm)

OPPOSITE Costa Vavagiakis, *Connie XXIII*, colored pencil, 14" × 14½" (35.5 × 37 cm)

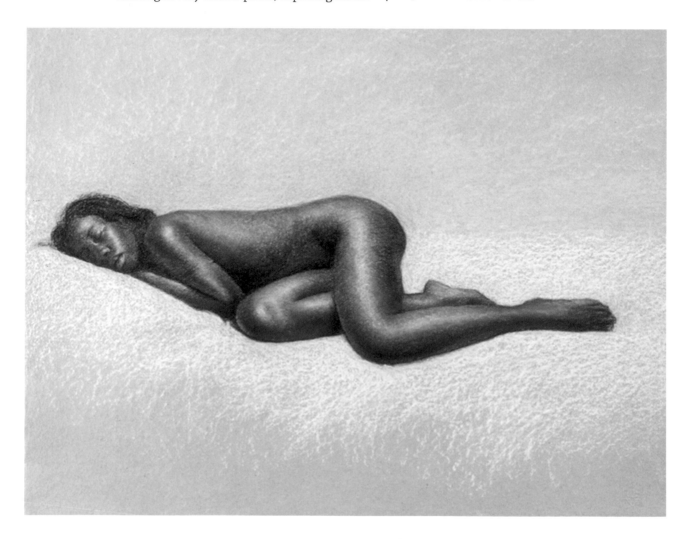

ARTIST BIOGRAPHIES

DOTTY ATTIE

Dotty Attie is a painter who lives and works in New York City. Represented by PPOW Gallery since 1988, she has exhibited extensively in the United States and abroad. Her work is in many museums and art institutions, including The Museum of Modern Art, The Whitney Museum, The Brooklyn Museum, The Walker Art Center, The National Gallery in London, and many others.

KEN CARBONE

Ken Carbone is a designer, artist, musician, author, teacher, and featured blogger.

He is the Co-Founder and Chief Creative Director of the Carbone Smolan Agency in New York City. Their client list includes: W Hotels, Morgan Stanley, Canon, The Chicago Symphony Orchestra, Knoll, Corbis Images, *Architectural Record Magazine*, Mandarin Oriental Hotel Group, High Museum of Art, and the Musée du Louvre. The agency's work is widely published and is recognized for excellence worldwide. Ken also teaches design and branding at the School of Visual Arts in New York City. www.carbonesmolan.com.

LISA DINHOFER

Lisa Dinhofer, painter, draughtsman, and printmaker, was born in Brooklyn, New York. Her work has been exhibited extensively both nationally and internationally. Her most recent solo shows were at The Century Association (New York 2016), Denise Bibro Fine Art (New York 2012), and Purdue University (Indiana 2010). Collected widely, Dinhofer's paintings and works on paper are represented in many public and private collections, including The Brooklyn Museum, the New York Public Library, City College (CUNY), and many more. A recipient of numerous awards, she has received a National Endowment for the Arts (NEA) Individual Fellowship Grant and the MacDowell Colony Fellowship.

Lisa Dinhofer's work has been reviewed and profiled in several publications, including *Arts* magazine, *ARTnews*, and *Drawing* magazine. She has also written feature articles about drawing for *Drawing* magazine.

Dinhofer is a graduate of the New York City public school system. She went on to receive her BA, with honors, from Brandeis University and an MFA from the University of Pennsylvania. Currently, Dinhofer is on the faculties of the Art Students League and The National Academy Museum and School of Fine Art in New York City.

In 2003, she completed a 90-foot glass mosaic mural, *Losing My Marbles*, commissioned by MTA, Arts for Transit. This public work is located at the Times Square, 42nd Street subway station in New York City. Lisa Dinhofer continues to live and work in New York City. For more information, please visit her website, www.lisadinhofer.com.

TOM DUNCAN

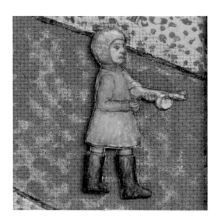

Tom Duncan was born is Scotland in 1939. At the age of eight he came to America. At the age of nineteen he studied sculpture at the Art Students League for two years, then studied sculpture for three years at the National Academy of Design in New York City. At both schools he won scholarships. He won a number of prizes at the National Academy of Design while still a student. He moved to Westbeth Artists Housing in New York City in 1970 and still resides and works there.

In 1971 Duncan joined the Prince Street Gallery and had four one-man shows there. He exhibited with G.W. Einstein Gallery for four years. For the past fifteen years he has been showing his work at the Andrew Edlin Gallery, having a number of one-man shows there, most recently in 2014. His work is shown nationally and internationally.

His work has been shown in the American Visionary Museum. His large sculpture *Dedicated to Coney Island* is there now on extended loan. This sculpture was exhibited in the Halle St. Pierre Museum in Paris, France, in 2013. Recently, he had a new piece, *Inside-Outside*, at the Armory Show in New York City. Duncan won an Adolph Gottlieb Lifetime Achievement grant in 1996. His work has been written about in many publications, including the *New York Times*, *Art in America*, and *ARTnews*. In 2003 a video was made about his work. To learn more about Tom Duncan's work please visit the Andrew Edlin Gallery at www.edlingallery.com or 212 Bowery, New York, NY 10012.

AUDREY L. FLACK

Audrey L. Flack (born May 30, 1931 in New York) is a highly celebrated American artist who pioneered the genre of photorealism. As the only women in the groundbreaking group, she introduced a new form of subject matter that broadened the entire movement. Audrey Flack and Mary Cassatt were the first women artists to be included in Janson's *History of Art*.

Flack graduated from Cooper Union in New York City where she was later awarded an Honorary Doctorate as well as the St. Gaudens Medal for achievement in art. She received a scholarship to study under Josef Albers at Yale University where she graduated with a bachelor's degree in fine arts. Furthering her studies, she attended New York University's Institute of Fine Arts where she studied art history. In May 2015, Flack received an honorary Doctor of Fine Arts degree from Clark University, where she also gave a commencement address.

The J.B. Speed Art Museum in Louisville, Kentucky, organized a retrospective of her work that traveled to The Butler Institute in Youngstown, Ohio, and The National Museum of Women in the Arts in Washington, DC. She lectures nationally and internationally and has been a professor of drawing and anatomy teaching at Cooper Union, NYU, and Pratt Institute and is currently teaching at the New York Academy of Art.

Flack's work is in the collections of The Museum of Modern Art, the Metropolitan Museum of Art, The Whitney Museum of American Art, the Solomon R. Guggenheim Museum, The Canberra Museum in Australia, and other museums throughout the world. Audrey Flack's *Leonardo's Lady* was the first photorealist painting purchased by the Museum of Modern Art. Her legacy for photorealism lives on to influence many American and international artists today.

In the early 1980s, Flack began sculpting monumental bronzes of women and goddesses that are now sited throughout the United States. Her use of iconographic and mythological elements to communicate the strength, intelligence, and beauty of women has changed the face of public sculpture.

DAN GHENO

Born in 1955, **Dan Gheno** grew up in Santa Barbara, California, and later moved to New York City where he works at his art and teaches. He exhibits regularly, both nationally and in New York, at locations that have included the Museum of the City of New York, the National Academy Museum, the Butler Institute of American Art, the New Britain Museum of American Art, the Caro Gallery, the Limbo Gallery, the National Arts Club, the University of Hartford Art Gallery, Westmont College, and Union County College.

Gheno's work is included in several public and private collections, including the Museum of the City of New York, the New Britain Museum of American Art, the Butler Institute of American Art, and the Griswold Museum, Connecticut.

Gheno is a member of the Pastel Society of America and the Allied Artists of America. His awards include a Rome grant from the Creative Artists Network. His artwork and writings have appeared in various magazines and books, including *American Artist Magazine*, *Drawing Magazine*, *The Artist's Magazine*, *Oil Highlights*, *Pastel Highlights*, *Portrait Highlights*, *The Best of Pastels II*, *Classical Life Drawing Studio*, and on the cover of *The Best Sketching and Drawing*. His work was included in the book *Painting the Town*, from the Museum of the City of New York. Gheno is the author of *Figure Drawing Master Class: Lessons in Life Drawing*, recently published by North Light. He was the art critic for the *Santa Barbara News and Review* in the 1970s.

Gheno studied at the Santa Barbara Art Institute, the Art Students League of New York, and the National Academy of Design School.

Gheno is Professor Emeritus at the Lyme Academy College of Fine Arts in Old Lyme, Connecticut and teaches at the National Academy School and the Art Students League of New York. To learn more, please visit www.dangheno.net.

FRED MARCELLINO

Fred Marcellino was a designer and illustrator who was widely regarded as America's preeminent book jacket designer during the 1970s and 1980s before turning his focus to children's books.

He was born in Brooklyn in 1939, where he attended public schools. He later enrolled in Bayside High School, which featured an advanced art program. From there, he was accepted into Cooper Union, graduating with honors in 1960. In defining himself at that time as an abstract expressionist painter, he then chose to enter Yale University, where he felt he might achieve the advanced degrees necessary to pursue a career in teaching. After his senior year, he was awarded a Fulbright Scholarship to study in Venice. While there, he decided to change direction.

In 1964 he returned to New York. Having always been drawn to lettering as well as illustration, he quickly began receiving assignments from record companies to design their jackets. By 1970 his work was being noticed by publishers of books and magazines, who commissioned him to turn his attention to editorial illustration and book cover design. His work earned many awards, including the National Book Awards exclusive "Nevelson" for three years running. He worked for all major publishers, and completed about forty jackets per year, reading every manuscript in its entirety.

By the late 1980s, Fred Marcellino longed for projects of longer duration. He decided to try his hand at children's books. His first one was a storybook in collaboration with Tor Seidler, called *A Rat's Tale*. Next, he took on the classic *Puss in Boots*, with elaborate illustrations in colored pencil. This first attempt at a picture book (one in which illustrations are the major focus rather than the story) won a Caldecott Honor. He was the recipient of Cooper Union's Augustus St. Gauden's Medal. Marcellino completed seven more books, all widely acclaimed, before his death of colon cancer in 2001.

The Norman Rockwell Museum mounted a large exhibition of Marcellino's work, called *Dancing by the Light of the Moon*, in 2002. The show then traveled to the Los Angeles Public Library, the National Center for Children's Illustrated Literature (NCCIL) in Abilene, Texas, The Joslyn Museum in Omaha, the Houston Children's Museum, and the Stamford Museum, as well as others. In 2015 the Eric Carle Museum in Amherst, Massachusetts, presented its own large exhibition called *Fred Marcellino: A Renaissance Man*.

is a piece of heavy board with a window cut in the center. The bottom is a flat board. It's important to use PH-balanced mat boards. The best is called museum board, which is 100% rag. The mat will protect the work in several ways. It creates a hard, flat surface to back your work. The mat acts as a spacer between the glass or Plexiglas and your drawing. Over time, heat, damp, pollution, etc., can affect the wax and make it adhere to the glass. This is why a spacer, such as a mat, is important.

There are two ways to mat a piece. One way is to have the window of the mat cover the edges of the piece. You will lose a quarter of an inch all around. Another method is called floating. The window of the mat is cut a quarter of an inch larger than the piece and the drawing "floats" on the mat.

Use only **archival materials**. Archival means PH-balanced materials in which the acid inherent in the material is neutralized. I have seen many drawings where the paper the drawing is on is fine but the edges where the mat has touched the artwork are brown and discolored or the tape used to attach the work comes through and turns the area brown. This happens because the tape or glue and the mat are made of wood pulp or some other non-archival material. Over time, this will ruin your drawing. Framing your work with archival materials is a little more expensive but worth every extra penny in the long run. If you decide to have your work framed professionally always ask for archival materials. That includes the mats and any tape used to secure your piece.

As for the **glass or Plexiglas**, there are several choices. I would recommend UV protective Plexiglas. The UV rays are the harmful rays of the sun. These rays will make your drawing fade and lose the vibrancy of your

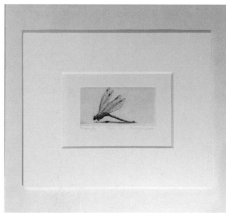

ABOVE Window mat with 2-ply museum board backing.

LEFT Window mat covering edges of artwork.

BELOW Window mat with artwork floating.

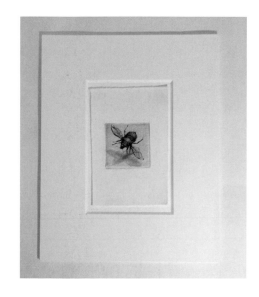

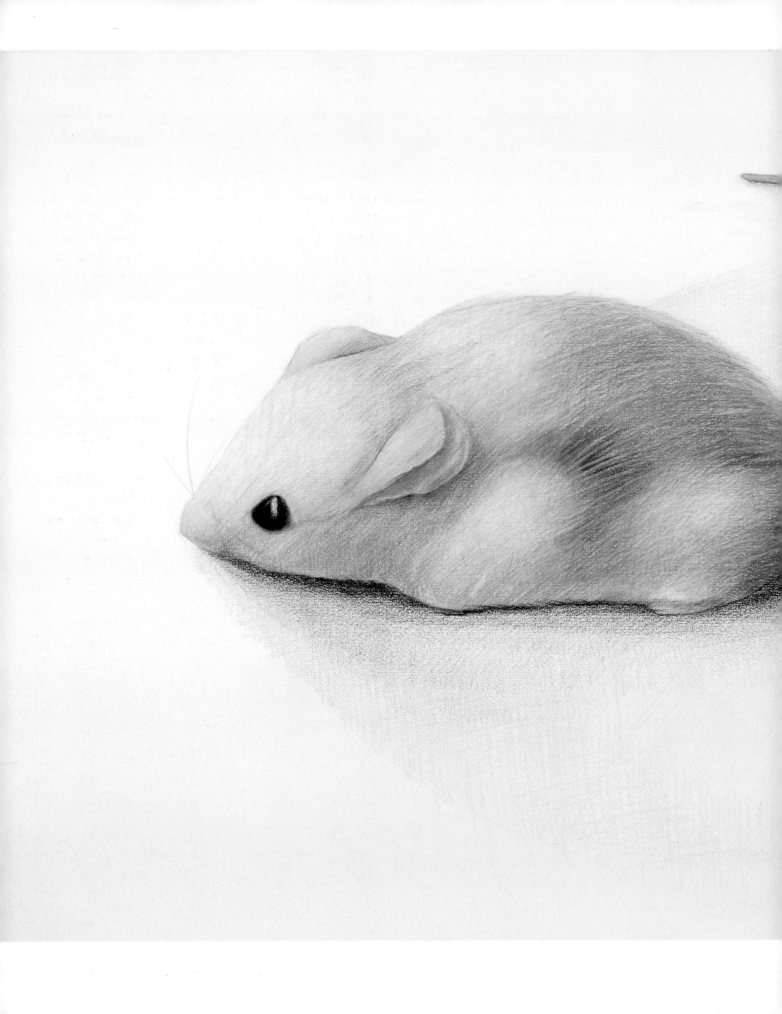

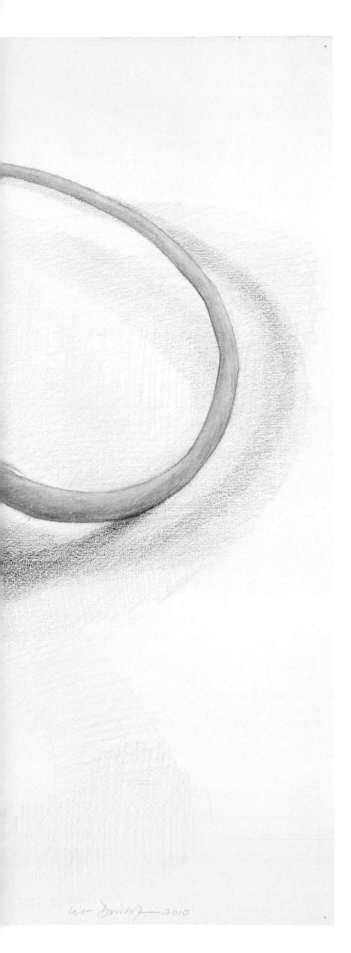

color. This glass or Plexiglas keeps the harmful UV rays from penetrating your drawing. It is not complete protection from sunlight but it helps.

The differences between glass and Plexiglas are two fold. Plexiglas is lighter and will not break. Glass in the past was clearer. Today, I have not found any difference. There is now a type of Plexiglas called **museum glass**. This relatively new material is not only UV protective, it is also non-glare and does not distort the image in any way. It is quite expensive but is a wonderful new material. When you frame a drawing, photograph, print, watercolor, or any work on paper it appears as if there is nothing in front of the work; no reflections, no distortions, no color change, nothing. It is quite extraordinary.

When you are going to chose a **frame** and mat, there are certain things to keep in mind. The first and most important is presentation. You want your artwork to be the center of attention, not the mat, not the frame. I actually have a pet peeve when it comes to framing— colored mats. *Never use a colored mat.* Always, always go for a white or off-white mat. Think of the mat as an extension of your drawing. There are now many different whites in museum board. Spend some time and match the color of your drawing paper to the mat.

A frame is the transition from the wall to your artwork. Each home is different and the frame becomes a personal choice. The one exception is framing for an exhibition. When framing for a show simple is best: a white mat, with a very simple white, black, or silver stick frame.

Again the most important lesson here is to allow your work to come forward. The mat and the frame are only a support for your work, not the object.

The texture of the fur of the mouse is very different from a dragonfly's wing or a flower petal. I achieved this texture by carefully observing the transitions from one part of the form to the next. There are subtle differences in color and rendered by different pencils.

Lisa Dinhofer, *Mouse*, 2010, colored pencil on paper, 22" × 30" (56 × 76 cm)

THE CASE AGAINST PHOTOGRAPHY: AN ESSAY, AN OPINION

It's not that I don't like photographs. I take plenty myself. This is an argument for not using a photograph as the base of your drawing.

Beware of the Camera

Every day we are inundated by two-dimensional camera images. The camera is the middleman between the viewer and what's being viewed—granted, a very convenient one, but a middleman nevertheless. The camera is a machine that interprets what is seen. Have you ever looked at a photograph you have taken and thought, "That is not what I saw." You were right. Whatever image the camera presents, it is not what you saw; it's what the camera captured. Your eye is a wonderful organ. Your eye sees infinitely more than a camera ever will see. And your brain registers that image. The camera will take the air right out of your image. It makes decisions that you as the artist should make. The camera does several things that limit you:

- Flattens the image
- Changes the scale
- Changes the color
- Changes the focal point
- Removes texture
- Removes emotion
- Removes mood

Let us take this up point by point.

The camera flattens the image. One of the most important elements of a two-dimensional work of art is the edges between shapes. Your eye sees behind and around the object you are focusing on. It is your interpretation of the edge that is important.

The camera changes the scale. Your eye is discriminating as your brain interprets what you see. The combination tells you how large the object you are focusing on is, for example. The camera curves the peripheral picture plane, which means it loses focus at the ends and can distort the distance of the object. Your eye, on the other hand, adjusts for that curve.

The camera changes the color. A photo will go warm or cool, red or green; your eye perceives the color as it is in the real environment. As we explored in previous chapters, color is transformative. Photographs will emphasize local color—-the grass is green, but is it? Actually the edge of the grass maybe yellow, blue. or even purple depending on the light. Your eye can be trained to see it. The camera never will. Would a camera capture the *Starry Night* sky that Van Gogh painted? No. It's how he saw it; no one else. It's your choice.

The camera changes the focal point. The interpretation of what's important in your image is an integral part of the picture you want to present. For example, in a drawing of a tree in a forest, the tree you are drawing is the focal point among all the other trees in the forest. In a photograph of the same forest, the tree is just another tree, not the focal point. You see one particular tree as beautiful. But the photograph will not push this particular

THE NIGHTMARE:

...DRAWING FROM PHOTOGRAPHS!

sigh!

Lisa's Nightmare by April Tonin

tree forward or articulate the branches and give an accurate depiction of how the light falls. Your eye will.

The camera removes texture. In the flattening process that a camera does, texture, another integral part of a drawing or painting, is lost. How does the fabric feel, how hard is a brick, how luminous is the sky. Your eye comprehends the texture, the smell, the taste. All your senses are engaged when you are looking at something.

The camera removes emotion and mood. What is the greatest loss of all in a photograph? Emotion and mood. An artist creates a world and invites his or her audience in to share it. Why are we still mesmerized by a Rembrandt self-portrait? Because he communicates a lifetime of experience through his gestures and his eyes. We recognize his experience and we participate in it. We sit in a room full of Monet's water lily paintings and feel the silent beauty of the pond, and perhaps even hear the slow movement of the air and the water. I remember my mother saying to me that when she was pregnant and feeling anxious she would go to the Museum of Modern Art and sit in front of Monet's water lilies and feel calm. Can a drawing from a photograph do that? Something happens between your hand and your eye. That's Art. It can touch your soul.

Okay. I just spent two pages categorically dismissing the use of a photograph as the beginning and end of an image. The question now is can the camera be a tool for the artist? The answer is yes. But any tool needs to be learned and used appropriately.

In the *How to Use Photographs* section that follows, I'll give some pointers on how to use a camera effectively without losing the essential factors that make a successful picture.

HOW TO USE PHOTOGRAPHS

A camera can solve a memory problem. Therefore, photographs can be used as reference. They can give you the shape of the nose. It ends there. It is up to the artist to move beyond an image of the nose to the real nose through observation.

Foremost, do not become a slave to one meaning by transcribing what the camera saw exactly. What's the point? You already have the camera's interpretation. Do you really need another exact replica?

The key is to take more than one photograph. Some 20 or 30 might do. Perhaps even more. Move 360 degrees around your object taking images from many different angles—close and far, top and bottom. Be sure to print the photos. It's important to see all your photographs at the same time. Scrolling with a camera phone will not work.

Print your photos in black and white. Return to your subject matter for color.

Analyze the photograph by placing a grid on top so that you can see the spatial relationships clearly. Perspective is important here. Enlarging the photograph is a good idea. The larger the image, the easier it will be to draw the grid on top of it.

Do not lose sight of your subject matter. Return to the scene whether it is a landscape, a portrait, or a still life.

I repeat, use the camera as just another tool in your studio. Learn to trust your eye. This will happen if you draw consistently from life. I once did a large portrait drawing of my brothers and me. I took many photographs of the three of us because my brothers did not want to sit for the portrait. It was a revelation when I came to actually drawing their heads—I did not refer to the thirty or so photos I took in our first session. The only time I did look at a photograph for information was when I needed to see how the pant hit the shoe. I learned that I knew my brothers so well, how they stood and how they looked, the photographs just got in the way. If you can learn to do that—trust your own vision—then photographs can become an asset rather than a crutch.

Remember art is an inside job.

HOW I WORK

In follow up on my thoughts about photography, here is how I work. I build all my still life compositions so that I can carefully observe the objects. Opposite is an illustration of one setup, a Kaleidoscope. I wanted to portray glass marbles flying out of a conical form. I built the cone, placed it in a box, and hung the marbles from wires attached to the box.

OPPOSITE, TOP Here are photos I used as reference for the *Study for Kaleidoscope* drawing opposite.

OPPOSITE, BOTTOM Lisa Dinhofer, *Study for Kaleidoscope*, 2008, colored pencil on paper, 22½" × 24" (57 × 61 cm)
This is the finished study in color pencil for *Kaleidoscope*.

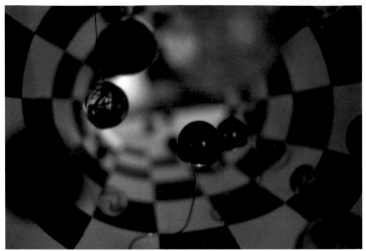
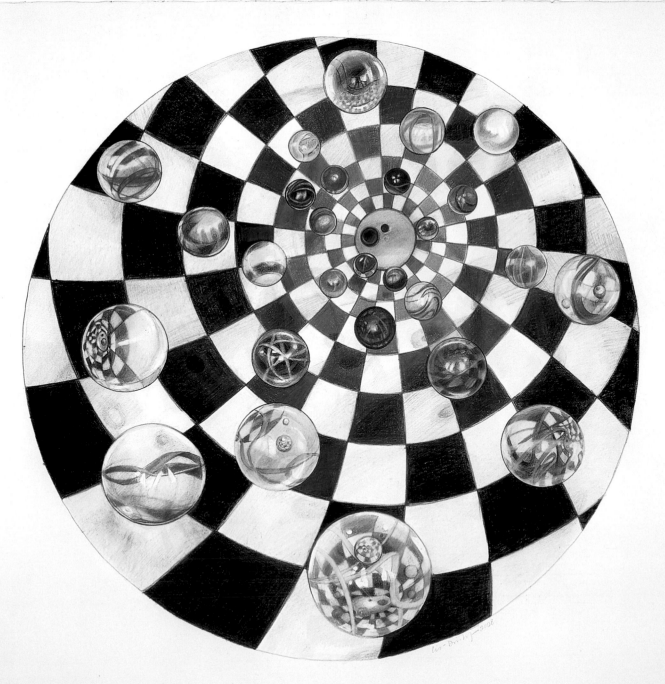

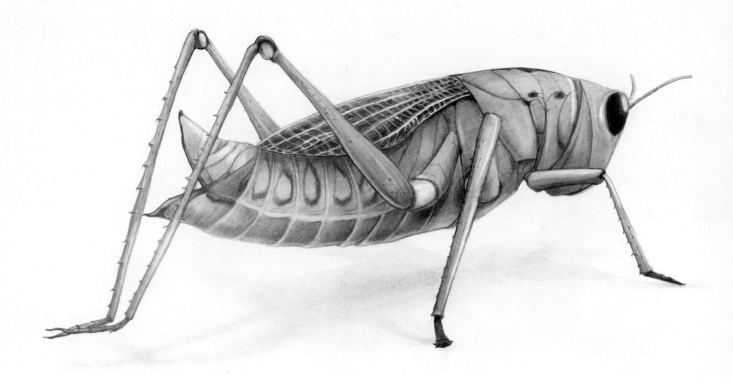

Lisa Dinhofer, *Grasshopper*, 2012, colored
pencil on paper, 22" × 30" (56 × 76 cm)
This drawing is 22 × 30 inches, almost 2 feet
by 3 feet. By enlarging the grasshopper by a
factor of ten, I have forced the viewer to see
this insect anew. And perhaps to marvel a the
pattern and color of it's exoskeleton.

OVERLEAF Lisa Dinhofer, *Study for Light Travelers # 2* (detail), 2007, colored pencil on paper, 22½″ x 25″ (57 x 63.5 cm)

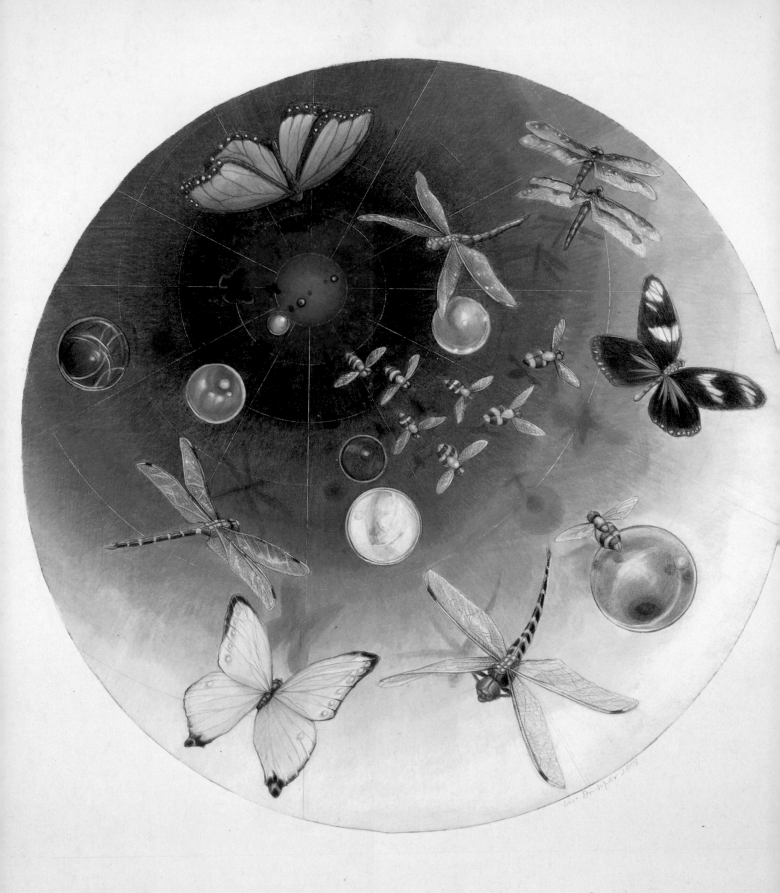

"Learning how to draw is learning how to see."
LISA DINHOFER, ARTIST AND AUTHOR